creating ART AT THE SPEED OF LIFE

30 DAYS OF mixed-media exploration

PAM CARRIKER

INTERWEAVE
interweave.com

editor Michelle Bredeson
associate art director Julia Boyles
design Karla Baker
photographer Joe Coca
production Katherine Jackson

Interweave Press LLC
A division of
F+W Media, Inc.
201 East Fourth Street
Loveland, CO 80537
interweave.com

Manufactured in China
by RR Donnelley Shenzhen

Library of Congress Cataloging-in-
Publication Data

Carriker, Pam.
Creating art at the speed of life :
30 days of mixed-media exploration
/ Pam Carriker.
 pages cm
Includes bibliographical references.
ISBN 978-1-59668-876-6 (pbk)
ISBN 978-1-59668-735-6 (PDF)
1. Handicraft. 2. Art--Technique. 3.
Mixed media (Art) I. Title.
TT857.C37 2013
745.5--dc23

2013005854

10 9 8 7 6 5 4 3 2 1

contents

INTRODUCTION
Driven to Create

My first book, *Art at the Speed of Life*, was about finding time to create art. Even before I'd met the deadline for that book, I began to jot down notes for a second book. The more immersed in being creative I became, the more inspiration bubbled out! There was just so much more I wanted to share about the process of actually making art. I'm a doer: it's not enough just to have a great idea; I have to actually roll up my sleeves, get my hands dirty, and go to work.

GETTING REVVED UP

Creation is the act of producing or causing something to exist. Finding the time to create art is a very important first step, like starting your car's engine and putting it into gear, but once you decide to make room for creativity in your life, it's time to step on the gas pedal and get going! In this book you'll find thirty exercises—a whole month's worth of journaling techniques—geared toward the fundamental elements of creating and assessing art. It's important to be able to assess your artwork in order to move forward and continually grow and become confident as an artist. This does not mean you need to create "perfect" art, but rather to have an inner discussion about what does or doesn't work in the art you create. Color, texture, shape, space, form, line, and value are the road signs marking the way as you navigate the world of mixed-media art.

ROAD TRIP

You'll use a handmade journal large enough to hold all thirty exercises as your vehicle on this journey, leaving behind the expectation of creating "perfect" art and instead concentrating on the creative process. Focusing on the product rather than the process can leave you frustrated and discouraged, much like having a flat tire. With a good map, the right frame of mind, and the necessary tools, you won't ever be caught stranded again. The journal you create will become a valuable reference tool to use in the future; a road map of sorts for those days when you may feel you've lost your way or just need to jump-start your muse and begin *Creating Art at the Speed of Life*.

HOW TO USE THIS BOOK

Over and over again, students in my workshops ask for an honest evaluation of their work. They want to know what they could do differently to make it better. Assessing your own work is something that can be learned and is an invaluable tool to move yourself further down your creative path. The thirty lessons in this book are grouped into chapters that each focus on a different element of art. Working in a handmade art journal will encourage you to experiment and find what makes "Art" happen, and you'll end your journey with a completed journal, a useful tool to refer back to again and again. This journal will be the perfect place to fearlessly explore the elements of art in a structured way and practice various mixed-media techniques, all while learning what makes your art visually pleasing.

The lessons are laid out in true workshop fashion, with a syllabus ("Quick Look") giving an overview of each chapter, objectives for each journal exercise, illustrated instructions to help you tackle each exercise, and a space for self-reflection and self-assessment of your work.

At the end of each chapter, there is an Open Studio section where you can see artwork from a variety of artists and find out how they assess their work. It's like standing behind artists in a gallery, eavesdropping on what they're saying about their own art and what makes that particular piece "work" for them. Included in each Open Studio is a Q&A with the contributing artists as they weigh in on a topic related to the chapter.

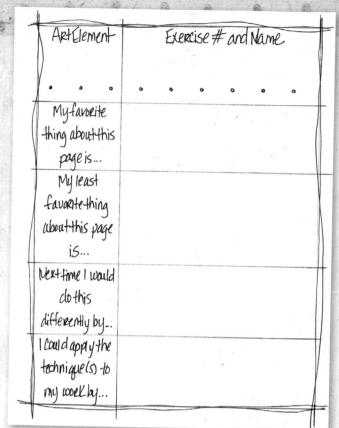

Art Element	Exercise # and Name
My favorite thing about this page is...	
My least favorite thing about this page is...	
Next time I would do this differently by...	
I could apply the technique(s) to my work by...	

Striving to grow more accomplished in art is part of what drives you to keep creating, and becoming adept at evaluating your own work is what propels you forward. By working in your own journal and using the self-assessment tools as part of your journaling process, you'll learn some new techniques and end up with valuable information about your own work, adding some important building blocks to your artistic foundation.

ASSESSING YOUR WORK

The blank template shown at right can be photocopied and filled in for each chapter's lessons. Adhere it to a page in your journal to keep a record of your progress and findings. For the first few lessons (except Lessons 1 and 2, which are tools that don't need to be assessed), I included thoughts on my own pages to give you an idea of the kinds of things to think about with your work. Later in the book, some of the assessment worksheets are intentionally left blank, freeing you to make your own findings. (For some of the lessons, both pages of the spread are filled with artwork. In those cases, you can tuck your self-assessment page into the journal or keep it in a separate journal.)

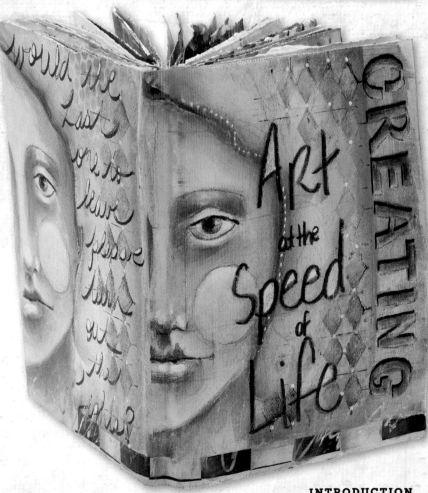

the *Handmade* JOURNAL

This journal will hold all of the exercises in this book. You'll have space for a two-page spread for each—one page for the lesson and one for assessing your work—with the exception of Lessons 1 and 2, which will be the first two pages of your journal and are tools themselves that won't need assessing.

SUPPLIES

Two sheets of watercolor paper, 22" × 30" (56 × 76 cm) each

Bone folder

Awl

Upholstery needle

Waxed linen thread

Bookbinding tape or other cloth tape

One 12" × 12" (30.5 × 30.5 cm) sheet of Sticky-Back Canvas (Claudine Hellmuth Studio brand)

1 Fold one 22" × 30" (56 × 76 cm) sheet of watercolor paper in half widthwise and score with the bone folder. Tear the paper on the fold.

2 Fold each of the two 22" × 15" (56 × 38 cm) horizontal pieces in half widthwise, score, and tear on the folds.

3 Fold each of the four 11" × 15" (28 × 38 cm) horizontal pieces in half widthwise, score, and tear on the folds.

4 Fold each of the 7½" × 11" (19 × 28 cm) pieces in half widthwise and score. Do not tear. These are your folios. Repeat Steps 1 through 4 with the second sheet of watercolor paper.

5 Open three folios and stack them together to form a signature. With the awl, punch holes in the fold in three places: 1" (2.5 cm) from the top, in the center, and 1" (2.5 cm) from the bottom. Do this to make five signatures (with one folio left unused).

WHAT KIND OF PAPER SHOULD I USE?

Like most paper, watercolor paper is sold by weight. (The weight refers to a ream of 500 sheets of paper.) You can find it in 90lb, 140lb, and even 300lb weights. Sometimes you'll see the term gsm (grams per square meter) instead of lb. The basic rule of thumb is that the heavier the paper, the thicker, and less likely to curl, it will be. Watercolor paper also comes in either **cold press** or **hot press** finishes. Cold press has a rough texture to it, making it ideal for collage and heavy paint applications. Hot press is smooth, making it a good choice for drawing, transfers, and lettering. I prefer 90lb hot press for journal making. It gives you nice, strong pages that hold up to a lot of media, it's easy to sew through, and it will lie flat nicely once both sides of the paper are painted. I'd suggest trying out different brands to find the weight and finish that best suits your work style.

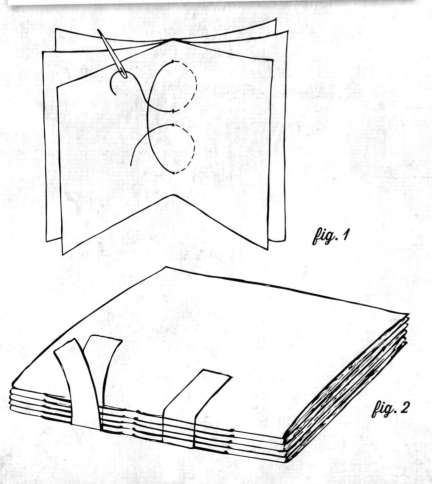

fig. 1

fig. 2

tips

★ Instead of Sticky-Back Canvas, you can use plain canvas from a pad the same way, and then use spray adhesive or other glue to adhere it.

★ Instead of painting the Sticky-Back Canvas, you can run it through an ink-jet printer to create your cover.

6 Thread the upholstery needle with a length of waxed linen thread that is roughly twice the length of the open book, or about 22" (56 cm).

7 Run the thread through the middle hole on the inside of the journal, leaving a 2"–3" (5–7.5 cm) tail. Go through the bottom hole on the outside, run the thread back up the inside of the signature, and go through the top hole on the inside of the journal. Go through the middle hole on the outside and tie the two tails together over the inside long stitch **(Figure 1)**. Do this for each of the five signatures.

8 Stack the five signatures and loop the bookbinding tape through the two stitches on the spines, as shown in **Figure 2**.

9 Cut one 7½" × 12" (19 × 30.5 cm) and one 1½" × 7½" (3.8 × 19 cm) piece of Sticky-Back Canvas. Peel the paper backing from half of the 7½" × 12" (19 × 30.5 cm) piece and adhere it to the front page of the journal. Peel the backing off the 1½" × 7½" (3.8 × 19 cm) piece and adhere the sticky side to the spine area of the cover. Peel the rest of the backing off of the 7½" × 12" (19 × 30.5 cm) piece and continue to adhere it to the back page of the journal. You now have a paintable cover for your journal.

Beautiful
Layers of
COLORS!
Analogous

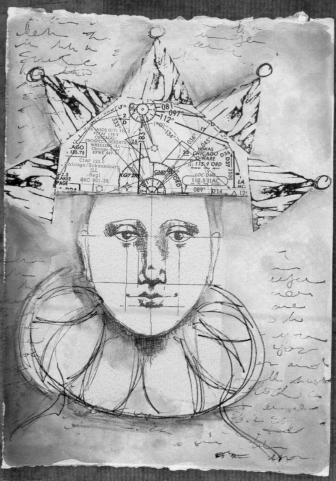

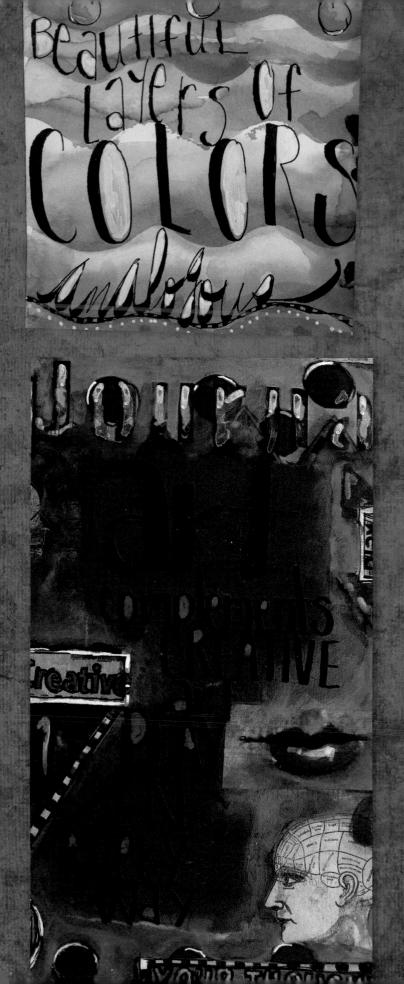

JOURNAL

Creative

Compliments
CREATIVE

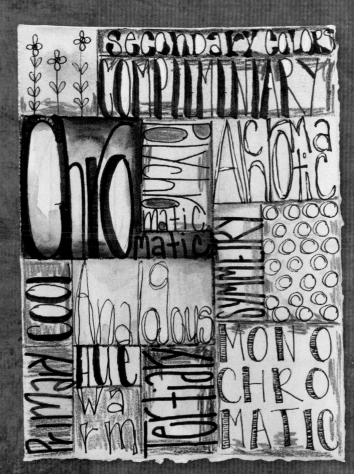

Secondary colors
COMPLIMINARY
Chro
matic
Primary cool
Analogous
Hue warm
Tertiary
MONO CHRO MATIC
Achromatic
symmetry

playful palette

EXPLORING THE ELEMENT OF COLOR

An artist's task is to present work in such a way as to create order and harmony and maintain visual interest. Sound hard? It's really much simpler than it sounds when you engage color. As you search for your own signature color palette you can learn some foolproof ways to play with color. Included are some do's and don'ts of combining colors, but these should be approached with an attitude of experimentation—after all, mixed-media artists are known for breaking the rules! By working through each color lesson in this chapter, you can explore your favorite color in a variety of ways that will help you find your color comfort zone.

QUICK LOOK

lesson	objective
1 COLOR WHEELING	To create all the colors on the color wheel using the three primary colors and then create a visually interesting first page in your journal.
2 COLORFUL LANGUAGE	To use the language of color to "under journal" and create a vibrant page that reinforces color terms.
3 ANALOGOUS ANALOGY	To pair your favorite color with the colors on either side of it on the color wheel to create a page with colors that flow.
4 ONE COLOR AT A TIME	To use a variety of media in only one color to create a cohesive, monochromatic journal page.
5 IT'S COMPLEMENTARY	To explore your favorite color's complementary counterpart by using it as the main color on your journal page.

Color wheeling

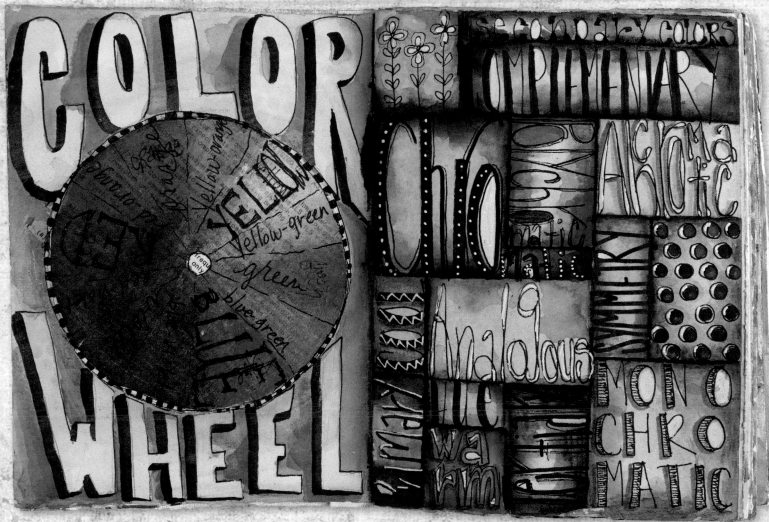

Lessons 1 (left) and 2 (right) share the first spread of the journal.

objective

To create all the colors on the color wheel using the three primary colors and then create a visually interesting first page in your journal.

By going back to the basics of grade school art class, you can rediscover the fun of mixing colors. In this lesson, we'll use a coffee filter substrate and watercolor paint to create a colorful journal page that is as beautiful as it is useful. The coffee filter allows the watercolors to blend with each other, forming all the colors of the color wheel. This will be the first page of your journal, and there won't be an assessment of this page.

SUPPLIES

Round coffee filter (in a size that fits your journal; you may need to trim one to fit)

Black permanent pen

Watercolor paint in red, yellow, and blue

Watercolor-type paint palette (with wells for mixing colors)

Brush(es)

Spray bottle filled with water

Bingo dauber bottle filled with acrylic paint recipe (page 165), or you can mix some right on your palette

Sequin waste scrap or other texture-making tool

Mixed Media Adhesive or other collage glue

PRIMARY COLORS

The three primary colors—red, yellow, and blue—cannot be mixed or formed by any combination of other colors. All other colors come from these three hues. When you mix primary colors with each other, you get secondary colors: orange, green, and violet. Tertiary colors—yellow-orange, red-orange, red-violet, blue-violet, blue-green, and yellow-green—are then created by mixing primary and secondary colors together.

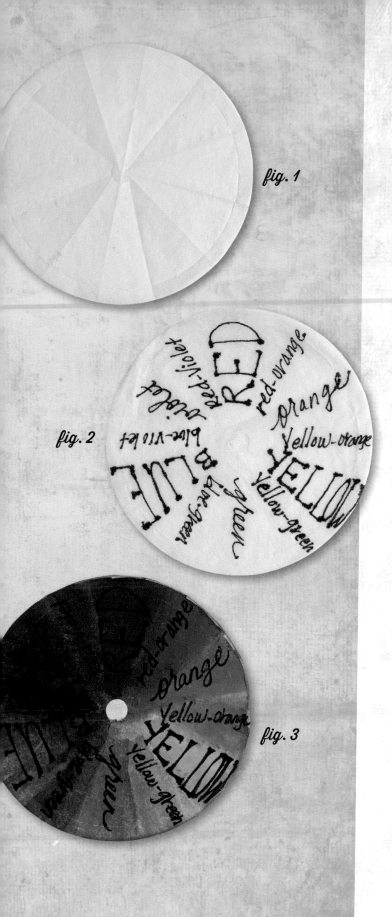

fig. 1

fig. 2

fig. 3

1 Flatten the coffee filter and trim it to fit the journal page if necessary. Divide the coffee filter into twelve sections by folding it in half, then thirds, then again in half **(Figure 1)**.

2 Use a black permanent pen to label each section with a different color name. For fun, try using a different writing style for the primary, secondary, and tertiary colors **(Figure 2)**.

3 Add yellow, red, and blue watercolor paint to three different sections of the palette.

4 Blend the paint to create secondary colors (orange, green, and purple) in the remaining sections.

5 Use half of each secondary color to create the tertiary colors.

6 Apply paint to the appropriate areas on the color wheel, allowing the colors to bleed into each other. Let dry **(Figure 3)**.

7 While the color wheel is drying, prepare your journal page by first spritzing it with water and then adding some acrylic paint glaze from your dauber bottle. Move the paint around to blend; let dry **(Figure 4)**.

8 Add more texture to the page with the sequin waste scrap and acrylic paint. Use a dry brush and a small amount of acrylic paint to "pounce" on top of the sequin waste. Do this randomly around the page.

9 Add this color wheel to your first journal page using Mixed Media Adhesive, applying it first to the page and then to the back of the color wheel. Carefully lay the color wheel in the desired position and apply more Mixed Media Adhesive to the top, working out any air bubbles that occur. Let dry **(Figure 5)**.

10 Add journaling and doodling using a black permanent pen.

11 Use additional leftover watercolor paint from your palette to paint in the background around your color wheel.

tip

★ Let leftover watercolor paint dry in the palette to re-wet and use in later lessons.

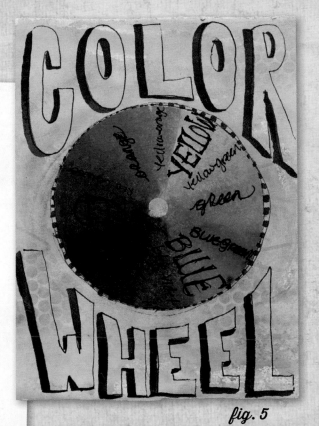

fig. 4

fig. 5

THE COLOR PURPLE

Purple is the color of my first artistic memory. It's the color of polka dots drawn ever so carefully on the freshly painted lavender of my bedroom walls. It's the color I tried to hide when I realized Mom might not be too happy about what I had done in my moment of creative genius. It's the color she later made me try to scrub off those walls with very poor results. They had not invented washable markers back then, but I am sure my little art foray contributed to their later arrival. My mom has long since forgiven my transgression, but it lives on as my first memory of creating art with the beautiful color purple.

LESSON 2

Colorful language

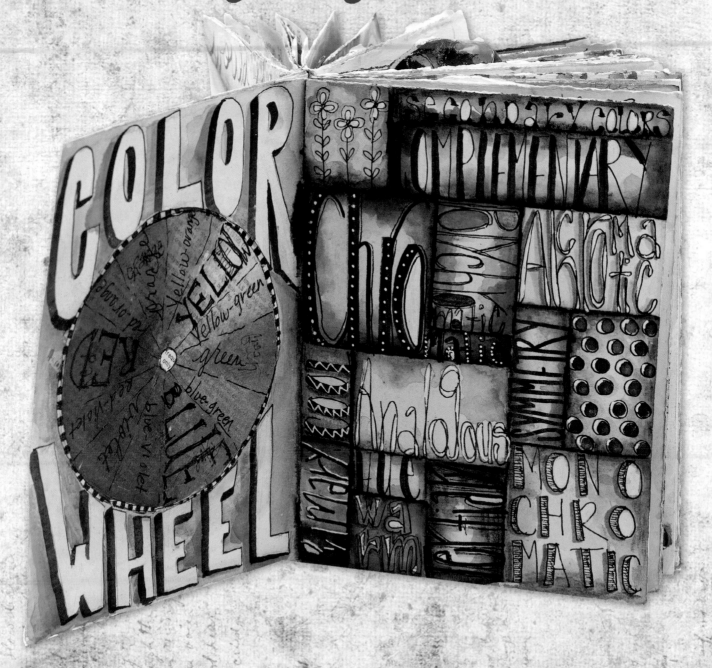

objective

To use the language of color to "under journal" and create a vibrant page that reinforces color terms.

Journals give you a place in which to document your journey as an artist. They are a visual reference that can be filled with notes, reminders, and findings, as well as beauty and art. As you create pages, you will begin to see your own artful language appear. Writing techniques, colors, symbols, and more will begin to appear with regularity. Listen to your art language. Let it emerge. Embrace it and be true to it. Every lesson, every page, will lead you to finding your unique style of expressing your art. In this lesson, you will use the language of color from the vocabulary words below and some creative writing techniques to create a fun and useful color reference tool in your journal. This will be the second and opposing page of the first lesson in your journal, and there won't be an assessment of this page.

SUPPLIES

Bingo dauber bottle filled with acrylic paint recipe (page 165) in your favorite color

Ruler

Water-soluble graphite pencil

Black permanent pen(s)

Water-soluble colored pencils

Brushes

Mixed Media Adhesive

White gel pen

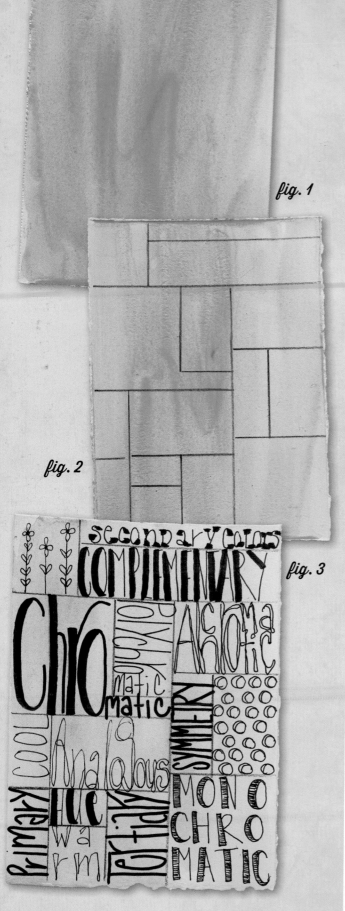

fig. 1

fig. 2

fig. 3

1 Use your custom bingo dauber bottle to paint the whole page in your favorite color. You can mix the paint recipe directly on your palette if you choose **(Figure 1)**.

2 Use a ruler and a water-soluble graphite pencil to section off the page, creating lines in many directions **(Figure 2)**.

3 Write the vocabulary words listed on the next page in the boxes formed by the lines using the black permanent pen(s). Use fun lettering, different colors, wavy lines, and different writing styles to make the page interesting. Leave some random boxes empty **(Figure 3)**.

4 In the empty boxes you can doodle fun little designs and images using the black permanent pen(s).

5 With water-soluble colored pencils, sketch around the inside of the boxes. Try to use colors that work with the color words **(Figure 4)**.

6 Activate the water-soluble pencil using a wet brush dipped in a bit of Mixed Media Adhesive.

note **Using the Mixed Media Adhesive will set the water-soluble pencil so it won't be reactivated when dry.**

7 Use white gel pen to add more details to finish off the page. Little "pops" of white take the page back to its original color and add great visual interest.

COLORFUL VOCABULARY

Here are a few terms you will encounter as you learn about color.

achromatic Free of color.

analogous Describes hues that are next to one another on the color wheel.

chromatic Having color.

complementary The colors opposite each other on the color wheel.

cool The colors on the green-blue-violet side of the color wheel.

hue Another word for color.

monochromatic Having one color.

polychromatic Having many colors.

primary colors Red, blue, and yellow. Cannot be mixed from other colors.

secondary colors Orange, green, and purple. Created by mixing primary colors.

symmetry The same on both sides.

tertiary colors Created by mixing primary colors with secondary colors.

warm The colors on the yellow-orange-red side of the color wheel.

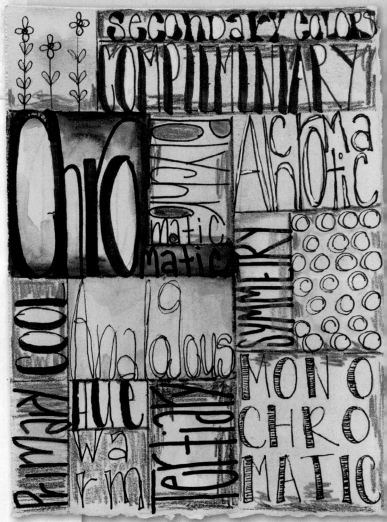

fig. 4

LESSON 3 Analogous analogy

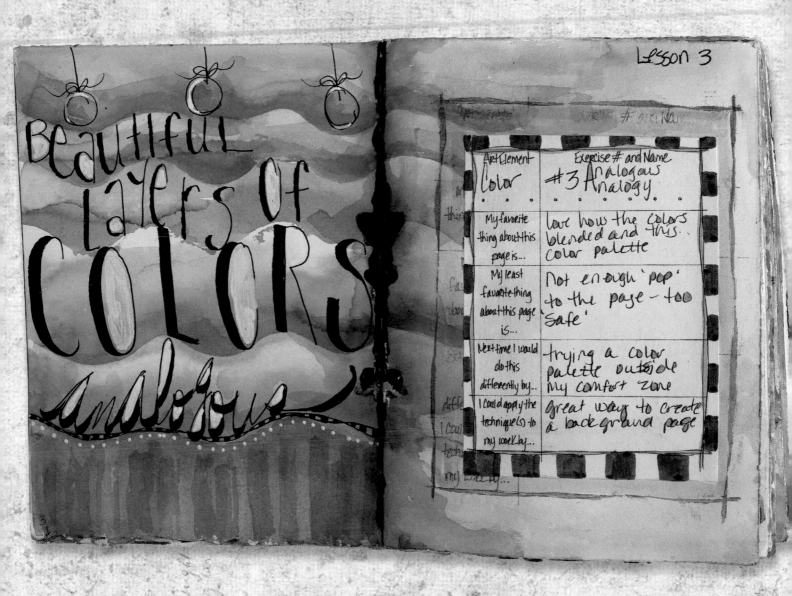

Beautiful Layers of COLORS analogous

Lesson 3

Art Element Color	Exercise # and Name #3 Analogous Analogy.
My favorite thing about this page is...	Love how the colors blended and this color palette
My least favorite thing about this page is...	Not enough 'pop' to the page - too 'safe'
Next time I would do this differently by...	Trying a color palette outside my comfort zone
I could apply the technique(s) to my work by...	Great way to create a background page

objective

To pair your favorite color with the colors on either side of it on the color wheel to create a page with colors that flow.

~~~~~~~~~~~~~~~~~~~~~~~~~~~~~~~~~~~~~~~~~~~~~~~~~~

Analogous colors are hues that are side by side on the color wheel. When used together they create an easy feeling of harmony in your artwork. By working with the color on either side of your favorite color, you can create a lovely, harmonious page that flows with little worry as to how these colors will interact with each other. You can use wet-on-wet techniques and blend analogous colors without fear of them turning muddy. Working with a wet-on-wet method allows for a very soft-looking page as the colors interact with each other. To complete the page, you can add words that describe that sense of harmony and similarity.

## SUPPLIES

Scissors

Old file folder or heavy cardstock paper that is at least the width of your journal page

Pencil

Spray bottle filled with water

Watercolor paints in your favorite color and the colors on either side of it on the color wheel

***note*** **If you saved the watercolors from Lesson 1, you can use those.**

Brushes

Black permanent pen(s)

White gel pen

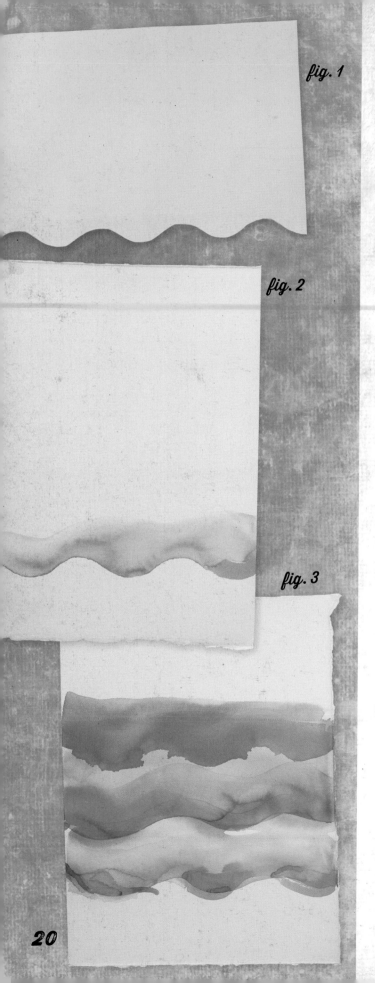

*fig. 1*

*fig. 2*

*fig. 3*

**1** Cut a rectangle shape from heavy paper to the width of your journal page and approximately 6" (15.2 cm) high.

**2** Draw a wavy line horizontally in pencil, and cut along the line to create a template **(Figure 1)**.

**3** Spritz the journal page with water.

**4** Place the template you created horizontally approximately 1½" (3.8 cm) from the bottom of your journal page. Begin with your favorite color and apply the watercolor paint with a wet brush along the cut edge of the template onto your journal page. Add water when necessary to help the paint "bleed" out from the wavy line **(Figure 2)**.

*note* **Remember to let the paint flow onto the opposing page, where you will add your assessment sheet.**

**5** Move the template up 1" (2.5 cm) and add one of the analogous colors in the same fashion.

**6** Move the template up 1" (2.5 cm) again and add the last color from the other side of your favorite on the color wheel **(Figure 3)**.

## SPREAD OUT

This is the first two-page spread in your journal. Allow paints and mediums to flow to the opposing page as you complete all of the following lessons. This will provide a nice background for your assessment page. The blank page (see page 5) can be copied and pasted directly onto one side of your two-page journal spreads for each of the following twenty-eight lessons. There are a few lessons that use both pages of the spread. In those cases, you can tuck the assessment page into the journal or keep it in separate place.

**7** Repeat Steps 5 and 6 using your favorite color and its analogous colors until the page is covered.

**8** Add more paint to the bottom of page to get the paint moving in a different direction. On my page, I painted vertical stripes **(Figure 4)**.

**9** When the page is dry, use the black and white pens to add words of harmony and doodles to enhance the page.

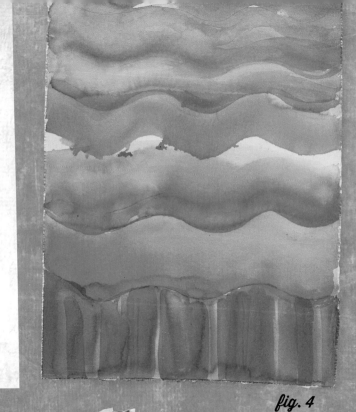

*fig. 4*

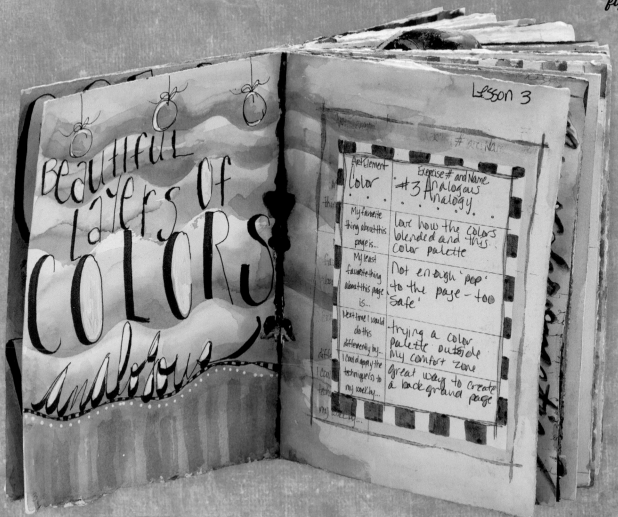

# LESSON 4 · One color at a time

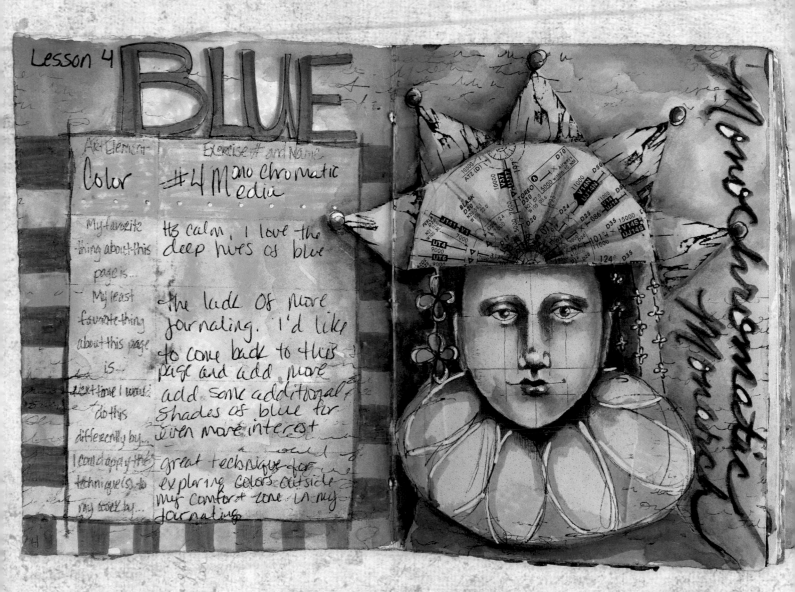

Lesson 4

## BLUE

| Art Element | Exercise # and Name |
|---|---|
| Color | #4 Monochromatic Media |

My favorite thing about this page is...

It's calm, I love the deep hues of blue

My least favorite thing about this page is...

the lack of more journaling. I'd like to come back to this page and add more

Next time I would do this differently by...

add some additional shades of blue for even more interest

I could apply the technique(s) to my work by...

great technique for exploring colors outside my comfort zone in my journaling

Monochromatic Monarch

## objective

*To use a variety of media in only one color to create a cohesive, monochromatic journal page.*

~~~~~~~~~~~~~~~~~~~~~~~~~~~~~~~~~~~~~~~~~~~~~~~~~~~~~~~~~~

By mixing several different types of media, in the form of collage, paint, and water-soluble mediums, you can create a visually pleasing journal page with only one color. Working with a monochromatic palette forces you to focus on the images, design, and layout of a page by taking the focus off of combining colors. Look around you and begin to gather together collage fodder in your chosen color and/or black-and-white images. You'll build a foundation for your page using unrelated collage elements and then tie them together with pen and a monochromatic palette.

SUPPLIES

Bingo dauber bottle filled with acrylic paint recipe (page 165) or you can mix a wash of color directly on your paint palette

Brushes

Paper towels

Collage papers in your chosen color for this lesson

Gel medium

Mixed Media Adhesive or other collage glue

Rubber stamps

Permanent ink pad

Black permanent pen

Water-soluble graphite pencil

Water-soluble colored pencils, crayons, and/or Gelatos in shades of your chosen color

White gel pen

fig. 1

1 Paint the entire page with your favorite color, using the bingo dauber bottle and blending it out slightly with a brush. While the paint is still wet, lay the rough side of a paper towel onto the painted page. Blot gently and lift straight up to leave a bit of texture on the page. Let dry.

2 Use watercolor paint in a slightly darker shade of your color and paint around the edges, blending inward. Let dry **(Figure 1)**.

3 Collage bits of paper in your favorite color onto the page with Mixed Media Adhesive or other collage glue. Use images, decorative paper scraps, napkins, and more, keeping to the shades of your chosen color or black and white **(Figure 2)**.

tip

★ Copy or print out images of your own artwork to use again in new ways. It's a great way to give new life to old work you might not have loved the first time around.

fig. 2

4 Stamp text or images using the permanent ink. Overlap onto the collage items to help unify the images **(Figure 3)**.

5 Use black permanent pens to add details tying the elements together.

6 Shade around the key elements with a water-soluble graphite pencil and use a wet brush to blend out the graphite **(Figure 4)**.

7 Use various shades of your color in different media (water-soluble colored pencils, crayons, or Gelatos) to shade the collage work and around the page. Experiment with the different effects achieved with each medium.

8 Journal some words using the water-soluble graphite pencil and then go over the lettering with a wet brush to activate it. Add highlights with the white gel pen.

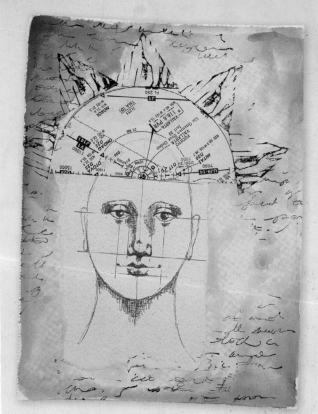

fig. 3

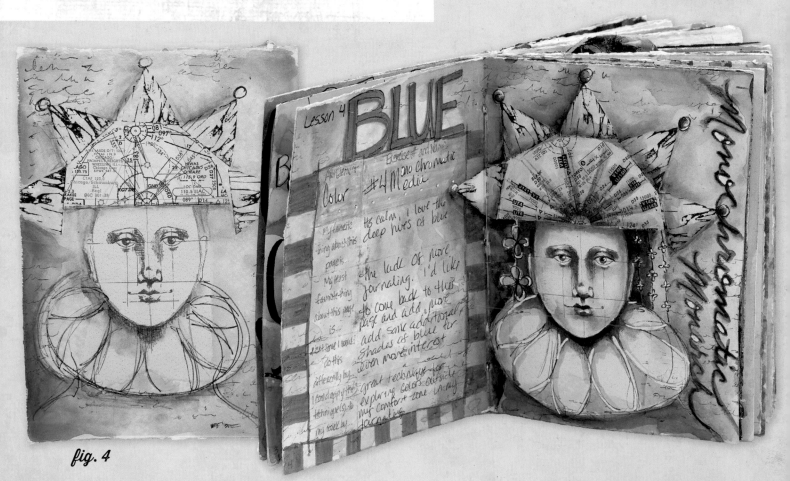

fig. 4

LESSON 5

It's complementary

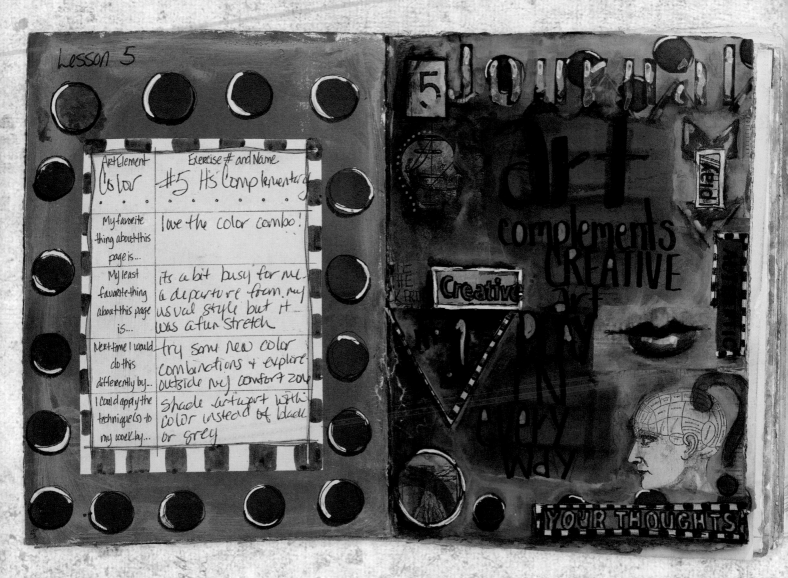

Lesson 5

Art Element Color	Exercise # and Name #5 It's Complementary
My favorite thing about this page is...	love the color combo!
My least favorite thing about this page is...	its a bit busy for me, a departure from my usual style but it was a fun stretch
Next time I would do this differently by...	try some new color combinations & explore outside my comfort zone
I could apply the technique(s) to my work by...	Shade artwork with color instead of black or grey

art complements CREATIVE

Creative

YOUR THOUGHTS

objective

To explore your favorite color's complementary counterpart by using it as the main color on your journal page.

~~~~~~~~~~~~~~~~~~~~~~~~~~~~~~~~

Complementary colors are those found opposite each other on the color wheel. Using them creates feelings of excitement, tension, and energy in your work. Just a "pop" of a complementary color adds great visual appeal to your journal pages. In this lesson we will go all out and explore your favorite color's complementary counterpart by beginning the page with this color and then working over it with your favorite color at the end. This will nudge you out of your comfort zone just a bit, while allowing you to explore your favorite color more fully and experiment with it in different ways.

## SUPPLIES

Bingo dauber bottle filled with acrylic paint recipe (page 165) in the complement of your favorite color

Brushes

Stamps

Permanent ink pad in complementary color

Mixed Media Adhesive or other collage glue

Collage fodder: sketches, scrapbook papers, junk mail findings, anything you like that has your complementary color in it

Water-soluble colored pencil in your complementary color

Black permanent pen

White gel pen

Water-soluble crayon in your favorite color

fig. 1

1    Paint the entire page in your favorite color's complementary color using the bingo dauber bottle and blending it out with a paintbrush. (I painted my page red, the complement of my favorite color, teal green.) Let dry.

2    Stamp or write the name of your color or other text randomly around the page using permanent ink or pens **(Figure 1)**.

3    Using Mixed Media Adhesive, collage bits of paper in your favorite color onto the page. Use images, decorative paper scraps, napkins, and more, keeping to the shades of your chosen color, creating a border around the page.

4    Color with the water-soluble pencil in your complementary color on and around the collage work to tie elements together. Add lines with the pencil in the open area of the page for later journaling. Activate the pencil with a wet brush dipped into the Mixed Media Adhesive. The adhesive will keep the water-soluble pencil from reactivating later **(Figure 2)**.

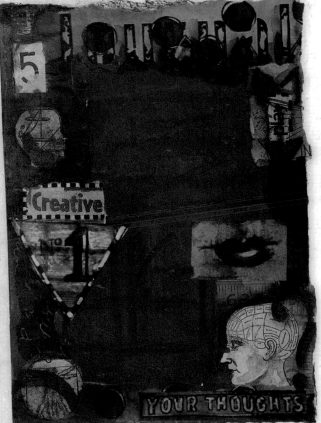

fig. 2

5   Use a black permanent pen and white gel pen to outline and doodle on the collage elements. Follow the designs as they present themselves in the collage work **(Figure 3)**.

6   Add journaling to the page. Write lines for journaling if desired, using a colored pencil. Add hints of a complementary color around the page to make your main color pop. A little goes a long way, and it's important to use the color in a way that allows the eye to follow it around the page.

7   Use a water-soluble crayon in your favorite color and activate it using a wet brush dipped into Mixed Media Adhesive. The crayon will turn to "paint" and cover over things and blend into the page. Use more water for a less opaque look.

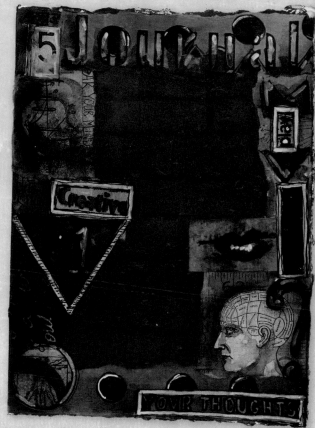

fig. 3

## CRITIQUE YOURSELF

Now that you've completed the first chapter in your journal, you've begun to establish a conversation with yourself (yes, it's sometimes okay to talk to yourself) regarding your artwork. Often, this conversation takes place without you even realizing it's going on, but by calling attention to it and putting it into writing, you can better assess your work and open the door to even more personal growth. You've played with color and maybe even found a color palette that appeals to you, along with some techniques and media you may want to explore further in your artwork. These are the things you should look to take away from each lesson, no matter where it's learned. So reflect on your work, write without fear, speak plainly, and have an honest and open discussion about where you want your art to go from each "last piece" you create. Listen to what your words and art are telling you, and watch your work improve with each new page.

# *open studio*

## DIANA TROUT

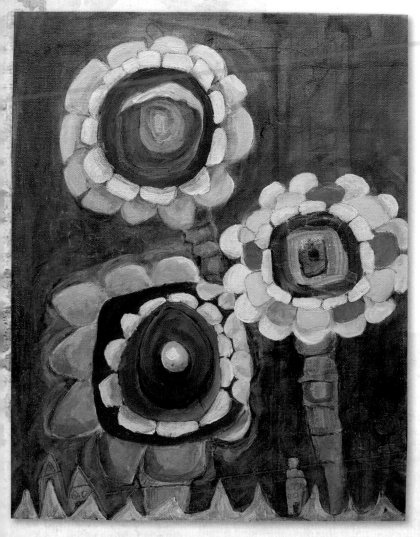

**↑ Honesty**
*Acrylics and graphite pencil on stretched canvas*

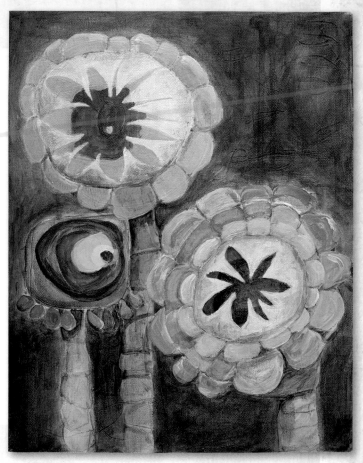

**↑ Sprightly**
*Acrylics and pencil on stretched canvas*

"Color excites me. It has been the basis of my artwork since childhood. Lately, I've been pushing the boundaries of making 'mud,' using grays and browns mixed from the complementary color schemes in my paintings. Flowers were a good choice as the subject for this series of paintings, because they are so often surrounded by mud and gray. Used carefully, the mud is a perfect foil for the brilliant color of the flowers."

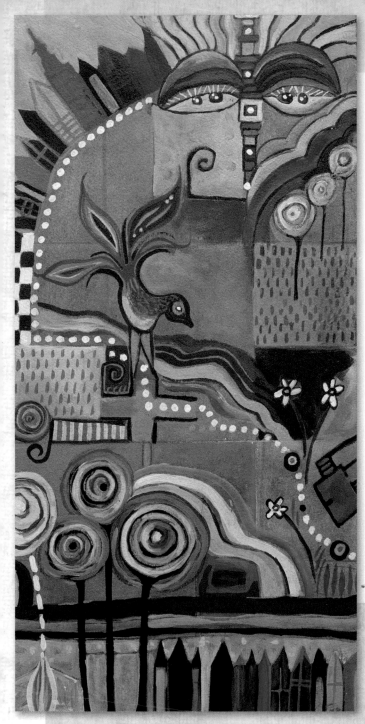

**Map to Happy**
*Acrylic paint on Arches Text Wove paper*

"After painting the paper solid green,
I scratched a grid in the paint while it was
wet. Starting in the bottom right corner,
I painted each square with the idea of
making a map to my idea of Happy. Maybe
this was inspired by game boards. Along
the way, I added elements and colors that
I thought I might see on my way to Happy."

# JILL K. BERRY

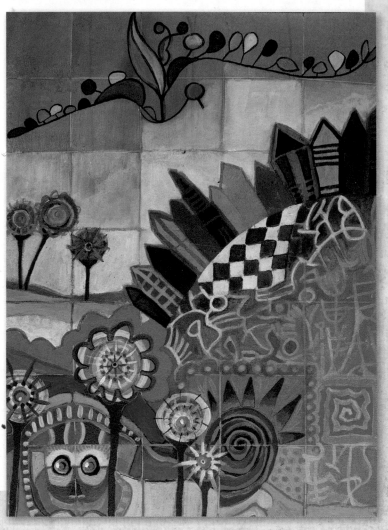

**Orange Jungle Town**
*Acrylic paint on Arches Text Wove paper*

"This painting was done from the bottom left
corner, one square at a time, without a plan,
on a piece of paper painted orange. I use
most of the symbols in this painting fre-
quently, but the jungle creature just showed
up, bright and new."

# Artist Q&A

## What was your favorite color as a child, and what is your favorite color now?

**SETH APTER** I distinctly remember that my favorite color crayon was Burnt Sienna. To this day, I love earthy and organic colors. And while many people say the "vintage" trend has run its course, I still love the shades of brown and sepia that are such a big part of that palette.

**LISA BEBI** As a child, I loved the color green—apple green and emerald green and all the in-between greens! I loved the colors found in grass and vegetation, probably because I grew up in Southern California, where the landscape is usually brown. I still do love green, but now I use it more sparingly. I tend to use pinks, turquoise, and oranges now. These colors really pump up greens.

**JILL K. BERRY** I grew up near the sea, and blue was my favorite color, all shades of it. Now I love so many colors, not one of them is my favorite. I love the entire rainbow.

**CHRIS COZEN** Green. As a child, whenever I would color or draw, I saved the green for last, and it always made everything come alive. I am still enchanted with green in all its forms, from chartreuse to gray-green. Mixing green paints is a magical process.

**CHRISTY HYDECK** Whenever I was lucky enough to receive a brand spanking new box of Crayolas, my favorite color was always Midnight Blue. My mother would occasionally wake us from our sleep to show us a particularly spectacular star-filled sky, and midnight blue was the color that reminded me of those magical moments. Nowadays, my favorite color varies. Sometimes it is deep red, others that perfect, warm shade of a buttery yellow.

**JANE LAFAZIO** Red has always been my favorite color to wear, and I continue to be drawn to it in artwork. Lately, I've been painting with warm shades of persimmon, pomegranate, and ochre.

**JULIE PRICHARD** When I was two years old, my parents moved us into the house I grew up in. My mom decorated the room in yellow and told me that yellow was my favorite color. I do not remember making the choice that my favorite color was yellow, but I elected to keep it. These days, I hardly use yellow in my artwork without toning it toward gold or by using it in a mix with other colors.

**RENÉE RICHETTS** As a kid, I liked blue in all its varieties. I now like red, red, and more red! Purple is very high on my list, too.

**LESLEY RILEY** It's easier to say what color I hated—pale, pastel green. It was the color of our school uniforms and my bedroom. I haven't liked pastels since! As for my favorite, it was blue and, yes, it's still my favorite, but I actually don't use it a lot in my art. I tend toward the warmer colors right now.

**JOANNE SHARPE** As a hip and happening child of the 1970s, I was a huge purple fan. These days I am consumed by anything aqua or turquoise. I am trying to channel a future move from the snow capital of upstate New York to the deep emerald-aqua Gulf of Mexico.

**MARY BETH SHAW** As a child I went through phases, much as I do as an adult. I specifically remember the "purple" phase, when I just *had* to paint my room purple. Yikes! These days, orange is a favorite of mine.

**DAWN DEVRIES SOKOL** I liked purple as a kid but really steer away from it now. I also liked pink (I had a pink bedroom), and it's one of the colors in my typical palette now.

**DIANA TROUT** The 64 box of Crayolas was my source of color inspiration when I was a child. Periwinkle was my favorite! I remember the first time I read the name of it. It took a while to figure out how to pronounce it, but I loved that it had a "wink" in it and it made me think of birds and the ocean. I still love that subtle blue-violet and use it in my work, especially with yellow ochre and muddy greens.

**SUSAN TUTTLE** My favorite color as a child was pink—pink room, pink clothes, pink stuffed animals—too much pink! In college, at music school, I tossed out the pink in favor of artsy black and dressed in it from head to toe, including cherry black lipstick. These days, I have lots of favorite colors and color combinations. A single splash of color against a neutral palette wows me—especially if it is a splash of red or yes, even pink!

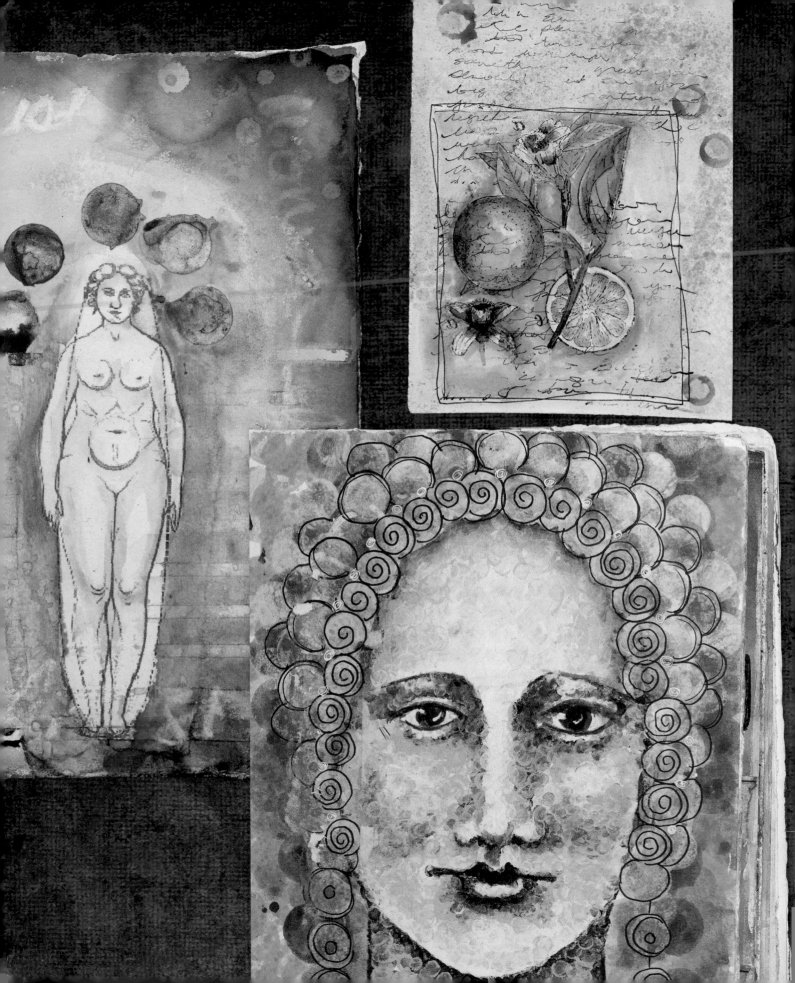

# tactile by nature

## EXPLORING THE ELEMENT OF TEXTURE

As a mixed-media artist, you can use texture to evoke a response to your work. Texture calls out to be touched, to be viewed more closely, and adds infinite interest to a journal page or a work of art. Experimenting with texture is important in the development of our artistic abilities, and what better place to freely play with texture-making tools and mediums than in an art journal? My goal for this chapter (and the entire book) is not to introduce you to myriad new tools and products, but rather to reintroduce you to the possibilities of what you may already have, or what is readily available, and to occasionally bring something new into the mix for added experimentation.

## QUICK LOOK

| lesson | objective |
|---|---|
| **6** UNDER WRAPS | To use plastic wrap and salt to create quick, organic, textured backgrounds for journal pages. |
| **7** MULTITASKING MEDIUMS | To create interesting textured backgrounds using common household items. |
| **8** RUBBED THE RIGHT WAY | To find texture in everyday objects and use them to create graphite rubbing transfers. |
| **9** FIRST IMPRESSION(ISM) | To create a richly textured Impressionist-style portrait using a simple painting tool in place of a paintbrush. |
| **10** FAUX-TOSHOP COLLAGE | To layer textures and colors over each other to create a digital collage look. |

# LESSON
# 6

# Under wraps

Lesson 6

| ArtElement | Exercise # and Name |
|---|---|
| • • • • | • • • • |
| My favorite thing about this page is... | |
| My least favorite thing about this page is... | |
| Next time I would do this differently by... | |
| I could apply the technique(s) to my work by... | |

**INTENTIONALLY LEFT BLANK**

## objective

*To use plastic wrap and salt to create quick, organic, textured backgrounds for journal pages.*

~~~~~~~~~~~~~~~~~~~~~~~~~~~~~~~~~~~~

This technique has to be one of the easiest ways to get a really cool-looking background for your journal pages. No two will ever be the same, and it's guaranteed foolproof! These pages have the look of tie-dyed T-shirts without the mess that comes with the real thing, and you can create them so fast you won't believe it. Use them as is or as a base for more developed pages—either way, you're sure to be off to a great start when you've got things "under wraps"!

SUPPLIES

Spray bottle of water

Coarse salt (such as kosher salt from the kitchen)

Plastic wrap (such as Saran wrap)

Watercolor paint in two or three colors

Watercolor palette

Brushes

Permanent black pens

Sequin waste

Chalk ink (optional)

Water-soluble graphite pencil

White gel pen

fig. 1

fig. 2

1 Spritz the journal page with water using the water bottle. Make a wash (roughly four parts water to one part paint) of two or three colors of watercolor paint. Using a wet brush, quickly add paint to the page in a random fashion.

2 While the page is wet, sprinkle a bit of the coarse salt randomly around it. Rip off a piece of plastic wrap, large enough to cover the page, and set aside. Immediately cover with the plastic wrap and start to bunch and pull the wrap to create an interesting pattern. Set it aside to dry completely. Carefully remove the plastic wrap and brush off the salt **(Figure 1)**.

note *The salt pushes the paint pigment aside and absorbs the water, leaving organic little markings on the paper.*

3 Use permanent black pens to follow some of the random lines the plastic wrap created **(Figure 2)**.

4 Add some journaling, following the lines you just drew.

5 Use a scrap of sequin waste and chalk ink, or a dry brush dipped in a bit of paint, to stencil and add some extra subtle texture here and there **(Figure 3)**.

6 Shade one side of the line drawing with a water-soluble graphite pencil and then activate the pencil with water. This will give some depth to your design.

7 Use a white gel pen to add a few touches of white to the lettering to make it pop off the page.

fig. 3

FLAT OUT PERFECT PAGES

There are many ways to keep your pages from curling up on you. Painting both sides of the page will help the page lie flat, so even if your page curls initially, once you move to the back side of it, things will even out. If you want to make sure your pages stay flat from the get-go, paint both sides of the paper with a thin coat of gesso. This will give the page a heavier feel, and the paper will accept the media a bit differently, but it's a good way to prep the pages if you truly want them to lie flat. Gesso also comes in a handy spray form that can make quick work of page prepping. You can also just lay a couple of heavy books on top of your journal at the end of the day, and by the next morning the pages will be nice and flat; this is what I did with my journal.

Multitasking mediums

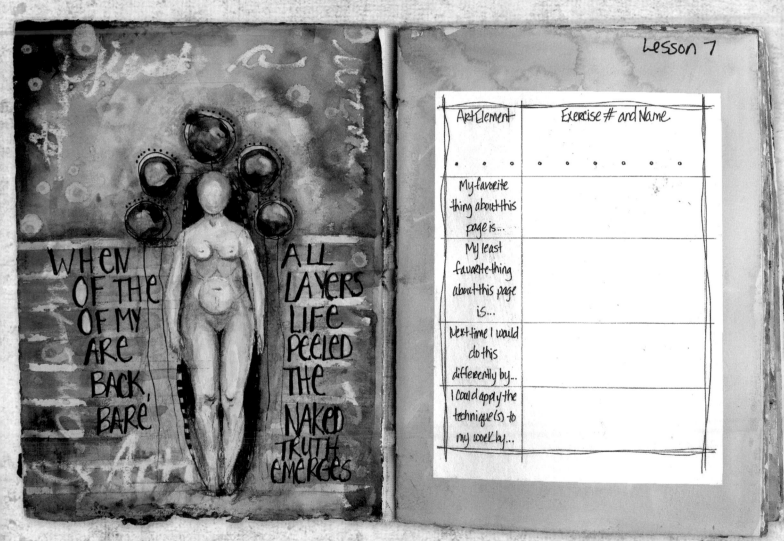

Lesson 7

Art Element	Exercise # and Name		
• • • •	• • • • •		
My favorite thing about this page is...			
My least favorite thing about this page is...			
Next time I would do this differently by...			
I could apply the technique(s) to my work by...			

INTENTIONALLY LEFT BLANK

objective

To create interesting textured backgrounds using common household items.

~~~~~~~~~~~~~~~~~~~~~~~~~~~~~~~~~~~~~

Finding new uses for common supplies from around the house is always an exciting adventure—one that doesn't require a trip to the craft store! Texture and depth can be quickly and easily achieved through layering both art supplies and ordinary household items. Keep your eyes open as you go about your daily routine to see if there are things that can pull double-duty with your artwork as well! In this exercise, we will combine some plain old rubbing alcohol, a crayon from an Easter egg kit, and removable masking tape with other art supplies to create a textured look that has some depth to it.

## SUPPLIES

One image to use as collage focal point (see pages 170–171 for images you can use)

Mixed Media Adhesive or other collage glue

Translucent crayon (like the kind that comes in egg-coloring kits, or you can find one in a craft store)

Brushes

Bingo dauber bottles filled with acrylic paint recipe (page 165) or you can mix on your palette

Coarse salt (such as kosher salt)

Removable masking tape

Rubbing alcohol

Watercolor paints

Watercolor palette

Heat gun or tool (optional)

Permanent black pens

White gel pen

fig. 1

fig. 2

## tip

★ You can use any images you like on your journal pages, from photos to sketches to images cut from magazines or newspapers. To make things even easier for you, I have included several of my own images as clip art in the back of this book (pages 170–171). Just copy and cut out for fast and easy journaling!

★ If you want to remove the wax, you can heat it gently with a heat tool (gun or iron) and blot with a paper towel. It gives a nice soft look to the crayon lettering.

1  Glue an image to your page using Mixed Media Adhesive. Let dry.

2  Use the wax crayon to journal some words around the page, creating a resist to the paint that will be applied later. (The darker the paint colors you apply, the greater the contrast you will have with the waxed areas.)

3  With a wet brush, dampen the page everywhere except for the inside of the image. By keeping the image dry and adding water everywhere else, the paint will naturally pull away from the image toward the damp parts of the page. Use the bingo dauber bottle to color in the background, making sure you work fast so it stays wet. Immediately add a sprinkle of coarse salt here and there. Let the page sit until dry. Brush off the salt to reveal the spotty texture **(Figure 1)**.

*note* The salt will push the pigment aside and soak up the water, leaving spotty marks on the page. The page must be very wet for this to work properly.

4  Using strips of removable masking tape, mask off some lines for journaling. You can find varying widths of it in home improvement stores, or even the drafting section of your local art supply store, or cut strips to the size you would like to use.

**5** Make dots by daubing the bingo dauber onto the page. While the paint is still wet, add a drop of rubbing alcohol to the center of each dot. Water and alcohol don't mix, so the paint will "run" away from the alcohol, leaving interesting circles on the page **(Figure 2)**.

**6** Using a wet-on-wet technique, wet the paper first and then add a wash (about three parts water to one part paint) of watercolor paint in a contrasting color around the perimeter of the page. Immediately add drips of rubbing alcohol. Let dry.

**7** Remove the tape.

**8** Add more watercolor paint (approximately one part paint to three or four parts water) to the image as well as around it. At this point you can paint over the image a bit, changing it from its original appearance, enhancing the journal lines, and creating shadows.

**9** Use a black permanent pen to journal and add details as desired. Add some highlights with the white gel pen.

## ARTISTICALLY FIT

Getting into shape physically requires repetitive exercise, and the same is true for your artwork. If you don't put in the time by exercising those art muscles daily, you won't reap the rewards of seeing your work develop into all that it could be. By repeating something over and over, you develop a pattern, a habit that will stick with you. Art journaling can be habit forming. If you spend the next month working on the projects in this book, you'll likely be in a journaling habit and find it hard not to take a few minutes a day to work in your art journal. All that exercise can lead you to a better understanding of both yourself and your art.

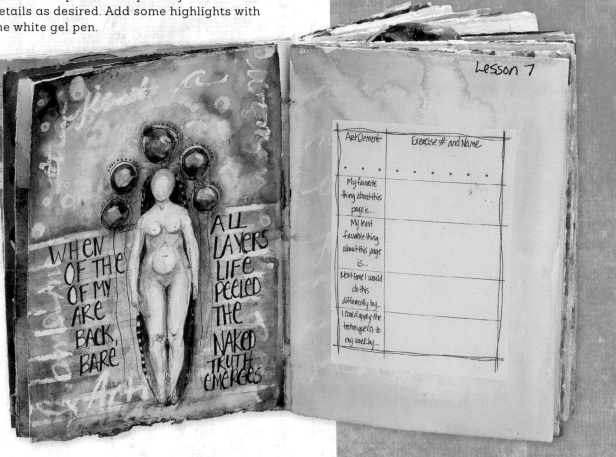

# Rubbed the right way

Lesson 8

| Art Element | Exercise # and Name |
|---|---|
| . . . . . . | . . . . . . . |
| My favorite thing about this page is... | |
| My least favorite thing about this page is... | |
| Next time I would do this differently by... | |
| I could apply the technique(s) to my work by... | |

heart of changing

**INTENTIONALLY LEFT BLANK**

## objective

*To find texture in everyday objects and use them to create graphite rubbing transfers.*

~~~~~~~~~~~~~~~~~~~~~~~~~~~~~~~~~~~~~~~~~~~~~~

As you know from the previous lessons, texture can be created, but texture can also be found in everyday objects from around the house and outdoors. Finding texture and creating your own rubbings allows you to collect a stash of transfer sheets that are both easy and fun to use in your artwork. It's also a great creative exercise for your artistic muse because you will start to look at things with an eye for texture. I love to keep these sheets on hand to add a touch of lovely graphite texture to my journal pages whenever I like.

SUPPLIES

Tracing paper

Graphite stick or woodless pencil

Bone folder

Watercolor paints

Watercolor palette

Acrylic paint in one color

Brushes

Pencil

Water-soluble graphite pencil

Black permanent pens

White gel pen

fig. 1

fig. 2

fig. 3

1 Make a rubbing of a textured object by placing the tracing paper over it and rubbing the graphite stick across it **(Figure 1)**.

2 Transfer the rubbing to your journal page by placing the tracing paper graphite side down and burnishing with the bone folder. Hold the tracing paper firmly in place and use small circular motions with the bone folder **(Figure 2)**.

3 Use watercolor paint to paint some shading around the graphite texture transfer and let dry **(Figure 3)**.

4 Make a thin wash, four parts water to one part acrylic paint, and with a small brush gently dab a little color onto all the graphite texture areas; let dry. This will seal the graphite and keep it from smudging **(Figure 4)**.

5 Dilute the acrylic wash used in Step 4 with more water to create an even thinner wash, and then paint over the graphite texture area to connect the elements together. Let dry, and then add some sketchy lines with a pencil **(Figure 5)**.

6 Outline some of the texture elements with the water-soluble graphite pencil, and then activate it with water to create some smudgy shadows. Add more watercolor paint to areas to make them stand out. Use a pencil and a ruler to create journaling lines in the negative space. Journal with the black permanent pens and add highlights with the white gel pen.

TEXTURE FIELD TRIP

Grab a few of your art friends or your kids (they will love this!) and head out on a field trip that's all about texture. Take your tracing paper and graphite stick (children can use crayons for a less messy adventure) and go for a walk, keeping an eye out for interesting textures to take home with you. You could even create a patchwork of the combined rubbings for a great collaborative project.

Here are some textures to look out for:

Tree bark

Cement

Gravestones

Bricks

Metal grates

Signs

Door hardware

Tiles

Leaves

fig. 4

fig. 5

LESSON 9

First impression(ism)

Lesson 9

Art Element	Exercise # and Name
.
My favorite thing about this page is...	
My least favorite thing about this page is...	
Next time I would do this differently by...	
I could apply the technique(s) to my work by...	

Impressionism

INTENTIONALLY LEFT BLANK

objective

To create a richly textured Impressionist-style portrait using a simple painting tool in place of a paintbrush.

~~~~~~~~~~~~~~~~~~~~~~~~~~~~~~~~~~~~~~~~~~~~~~~

I was thrilled to be able to attend an exhibit of Claude Monet's work while I was teaching in Paris in 2010. Having seen only prints of his work before that, I felt that everything seemed larger than life. Seeing how Monet's work progressed to become the Impressionist style we associate with his name was inspiring, to put it mildly. This exercise takes the focus off of painting with a brush and allows you to create a journal page using a simple dot-making tool and a pointillist technique made famous by another French Impressionist artist, Georges Seurat. Immerse yourself in texture as you pounce your way to creating an Impressionist-style journal page!

*"People discuss my art and pretend to understand as if it were necessary to understand, when it's simply necessary to love."*

**—Claude Monet**

## SUPPLIES

Basic portrait sketch

Acrylic paint in white, buff, Payne's grey, and red-violet

Painting palette

Loew-Cornell Style Stix (medium or large) or a new No. 2 pencil with a new eraser

Bingo dauber bottles filled with acrylic paint recipe (page 165) in your choice of background and hair colors

Water-soluble black pencil

Journaling pens in assorted colors

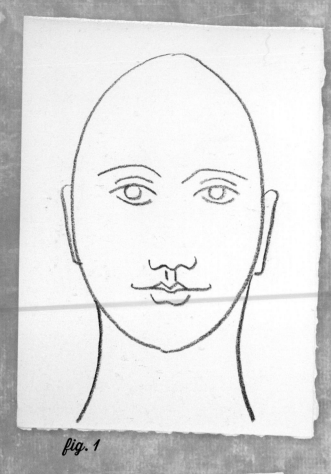

fig. 1

1    Transfer or draw a portrait sketch onto your journal page. Put small amounts of white, buff, and Payne's grey acrylic paint onto your palette **(Figure 1)**.

*tip*

★ You can draw a portrait of yourself or a friend or use one of my drawings on pages 170 and 171 . If you want to be extra-adventurous, try creating a landscape using this technique.

2    Using a Loew Cornell Style Stix or the eraser end of a new pencil dipped in Payne's grey, "pounce" onto the areas of the portrait that you want to shade. Repeat, reloading the pouncing tool with paint as needed **(Figure 2)**.

3    While the paint is still wet, continue adding dots of color using buff acrylic paint, allowing it to blend slightly with the Payne's grey. Add white acrylic paint to the highlight areas in the same fashion **(Figure 3)**.

4    Add a small amount of red-violet acrylic paint, in the same way, to the cheeks, lips, and a bit around the eyes.

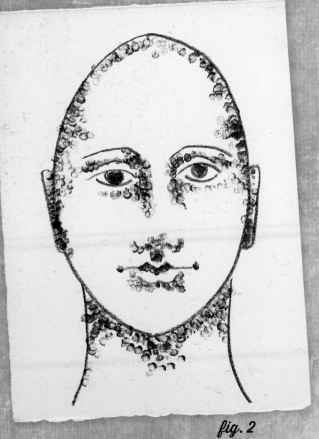

fig. 2

5  With the bingo dauber bottles add large dots to the background. Begin to form hair with the bingo dauber bottles as well **(Figure 4)**.

6  Continue adding buff and white acrylic paint dots to blend the colors a bit. The more you pounce in an area, the more blended the paint becomes.

7  Use the water-soluble black pencil to redefine the features of the face, and then activate it with a wet brush. Finish off the hair and the background using a combination of the bingo dauber bottles and the pouncing tool.

8  Add journaling and doodling with pens as desired. If needed, add a bit of shading around the new hairline with the water-soluble pencil and activate it with water.

## EASY TRANSFERS

To easily transfer a sketch, rub pencil (graphite) over the back side of the paper the drawing is on, then lay the graphite side down onto your substrate and simply trace over the lines of the drawing using a stylus or even a ballpoint pen. There are also transfer papers available that work like carbon paper but use graphite instead. You slide the transfer paper (graphite side down) under the drawing and trace with a stylus or ballpoint pen. Another way to transfer a pencil sketch is to lay the sketch face down onto the substrate and burnish the back side with a bone folder or spoon. There is usually enough graphite to transfer the sketch lightly onto the opposing paper. This method will create a mirror image of your original sketch.

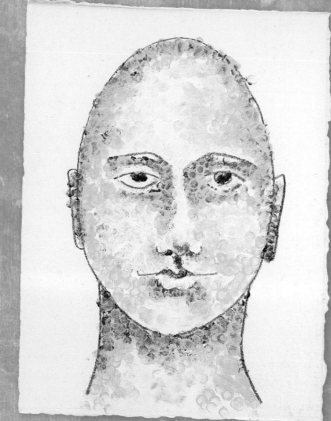

fig. 3

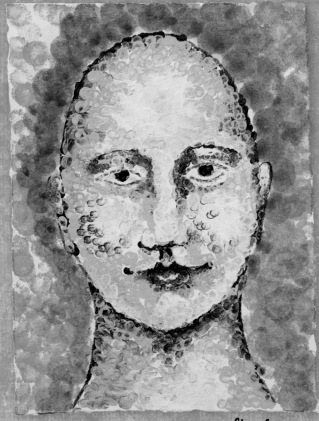

fig. 4

# Faux-toshop collage

Lesson 10

| Art Element | Exercise # and Name |
|---|---|
| . . . . | . . . . . . |
| My favorite thing about this page is... | |
| My least favorite thing about this page is... | |
| Next time I would do this differently by... | |
| I could apply the technique(s) to my work by... | |

10

**INTENTIONALLY LEFT BLANK**

BE FRUITFUL

## objective

*To layer textures and colors over each other to create a digital collage look.*

Ask my husband or my sons and they will confirm that I'm a technophobe. I can use technology to a point, and do so out of necessity, but when it comes to my artwork, I am not digitized! Photoshop baffles me, so for my layers I much prefer to cut my images with scissors, fill in the background with an actual paintbrush, and paste an object using glue. My hands get messy. I like that. I love the look of digital art, but not the process, so this exercise is all about creating layers similar to that of digital art, but using traditional art supplies instead of a keyboard.

## SUPPLIES

Stamp and permanent ink pad or permanent pen

Acrylic paint in three to five colors

Brushes

Old toothbrush

Bingo dauber bottle filled with acrylic paint recipe (page 165)

Rubbing alcohol

Sequin waste or other texture tool

Chalk ink pad

Inkjet transparency printed with image

Sponge brush

Hand sanitizer

Bone folder

Black permanent pen

Watercolor paints

Water-soluble crayons

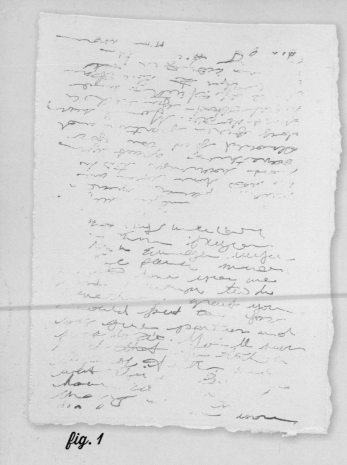

fig. 1

fig. 2

1. Stamp or write text with permanent ink.

2. Using a light color, paint the entire journal page in a wash of one part acrylic paint to three parts water, and let dry **(Figure 1)**.

3. Load a toothbrush with a thin wash (one part paint to three parts water) of another color of acrylic paint and run your thumb over it to flyspeck, or spatter, the paint onto the page. Using the bingo dauber bottle, make a few random dots on the page, and then add a drop of rubbing alcohol to the center of each dot to make a "watermark." This will add an aged appearance to the page.

4. Use sequin waste or another texture tool and chalk ink to stencil random texture around the page **(Figure 2)**.

5. Create an inkjet transparency of your chosen image following the manufacturer's instructions **(Figure 3)**. (See "Transparency Tips," at right.)

6. Use a sponge brush to apply a thin layer of hand sanitizer to the page where you want to transfer the image. Work quickly and immediately lay the inkjet transparency, ink side down, on top of the sanitizer. Pat the back of the transparency to ensure contact with the page, and then use a bone folder to further burnish and transfer the image. Gently lift up one corner to check that the ink has transferred and, if so, continue to lift off the transparency.

7. Use the black permanent pen to draw a frame around the transferred image **(Figure 4)**.

8. Paint a wash (one part acrylic paint to three parts water) of color on the outside area of the image and let dry.

9. Paint in the image using watercolors **(Figure 5)**.

10 Add journaling and doodling as desired.

11 Color around the outside of the framed image with water-soluble crayons and activate with water to blend outward. The crayon is more opaque than the other paint washes and will cover some of the underlayers. It's hard on your pens to write over the crayon, so it's a good idea to use it as a last layer.

*fig. 3*

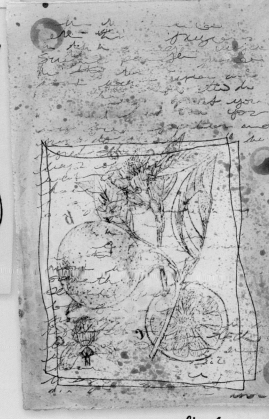

*fig. 4*

# TRANSPARENCY TIPS

Many variables—from the type of ink in your printer, to the type of painting medium you might mix with your paint, to the weather—can affect the outcome of a transfer. It takes a bit of experimentation to find a method that works for you, so when you do, stick with it! I'm sharing my favorite method in this exercise. It nearly always works, and if it doesn't, it's easy to wipe it off and try again. I love the way transparencies look a little different every time. That's part of their appeal, so instead of looking for a carbon copy, see the beauty in the results. You'll often find that slightly imperfect is really just right.

Here are some troubleshooting tips:

★ Avoid using the more expensive "no-smear" or "no-smudge" transparencies. A general rule is the cheaper the better for this technique. I use 3M Universal Inkjet Transparency Film.

★ If you lift the transparency and the image isn't transferring, add more hand sanitizer and repeat the process.

★ Can't get your hands on some sanitizer? Try using collage glue as your transfer medium. Just add a thin layer to the page, lay the transparency ink side down, and burnish until the design transfers to the page.

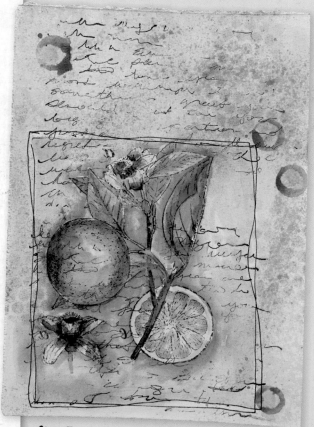

*fig. 5*

# open studio

## JULIE PRICHARD

**Nowhere** ➜
*Mixed media on canvas*

"**Nowhere** gives the illusion of being a highly textural painting, but it was created without heavy pastes and gels. With my process of adding and removing paint layers, I am able to create a heavily distressed surface, which I feel adds to the mystery of this painting. Although I am familiar with texture mediums, I choose not to use them because I find the process of uncovering the texture little by little to be a very exciting one."

## CHRIS COZEN

◀ **Textural Study #1**
*Fluid acrylic paints, torn vintage papers, printed acrylic skins, origami mesh, stamped elements*

"Layered papers and transparent elements really bring the visual texture into play. Applying transparent color over and around the papers increases the textural elements, pushing some forward and others to the rear. Stenciled layers applied between the paint layers give a sense of age and wear. Origami mesh gives a fabric-like element to the composition."

# Artist Q&A

## What are some unusual texture tools you use in your work?

**SETH APTER** Interpreting "unusual" as uncommon, I would have to say textured wallpaper pieces. They can be used to emboss or deboss and come in both geometric and more organic styles. They are my favorite texture tools by far.

**LISA BEBI** A copper sink scourer. I use it as a stamp. I load paint on it and stamp backgrounds. The result is a nice messy halo. I love that. It has a very subtle and airy effect.

**JILL K. BERRY** A goo spreader (a plastic applicator used for spreading glue). It works as a calligraphy and texture tool at once.

**CHRIS COZEN** A piece of open-weave rug grip material you can usually purchase by the yard at craft and home improvement stores.

**JANE LAFAZIO** Tried-and-true bubble wrap.

**RENÉE RICHETTS** Hands down (pun intended) my hands! Most especially my fingers. They've always been what I start and stop with when texturing any piece I create, even the metal work.

**LESLEY RILEY** My fabric stash. I love the textures that are formed by the wrinkles on the fabric literally caused by stashing it.

**MARY BETH SHAW** I enjoy using dental tools to carve texture into clayboard. I also have a plastic fence piece (from a childhood game) that makes a great texture when it's dragged through molding paste or wood icing.

**DAWN DEVRIES SOKOL** I like to sometimes use a pizza cutter to make straight lines or the little sewing tool that's like a smaller version of a pizza cutter and produces dashed lines. I also like to use anything that will scratch into wet paint!

**SUSAN TUTTLE** Photos I take of peeling paint, cement, worn surfaces, old leather, scratched windows, and mirrors, which I use as layers in Photoshop.

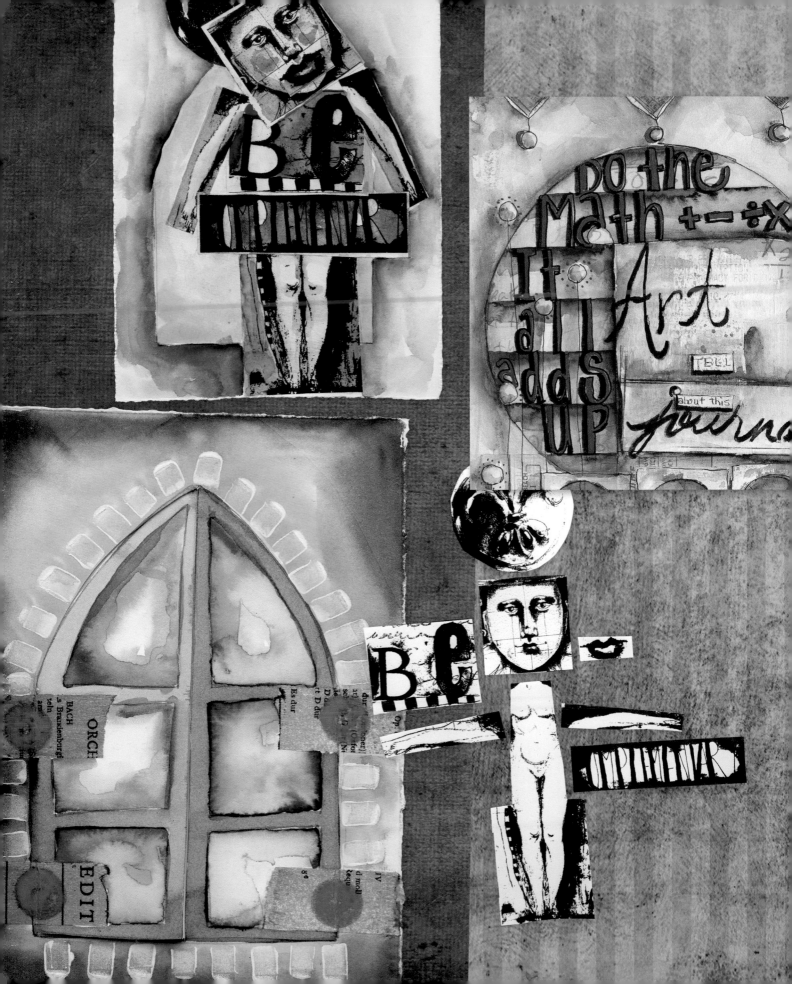

# setting boundaries

## EXPLORING THE ELEMENT OF SHAPE

Shape gives control and order to our work. Shape provides boundaries within which to work. Shape allows us to color both inside and outside the lines. Repetitive use of a shape can add order to our art, while organic shapes can take it in a direction that is unpredictable and interesting. Shapes are everywhere, and finding them is almost as much fun as using them. They can be drawn, added with shape-making tools, or even cut and pasted. In this chapter, we'll explore shapes: where to find them and how to use them effectively. Exploring ways to use shapes creatively and then assessing what works and even what doesn't will help us define the artistic boundaries within which we create!

## QUICK LOOK

| lesson | objective |
|--------|-----------|
| **11 GETTING INTO SHAPE(S)** | To create repetitive shapes in varying sizes to evoke a feeling of unity on the page. |
| **12 EPHEMERAL MATTERS** | To create a collage using random shapes cut from everyday ephemera and add color with media other than paint. |
| **13 CUTOUTS AND CUTAWAYS** | To create an interactive journal page that leads to glimpses of other journal pages. |
| **14 BUILDING CHARACTER** | To create a character by collaging shapes cut from previous artwork. |

# Getting into shape(s)

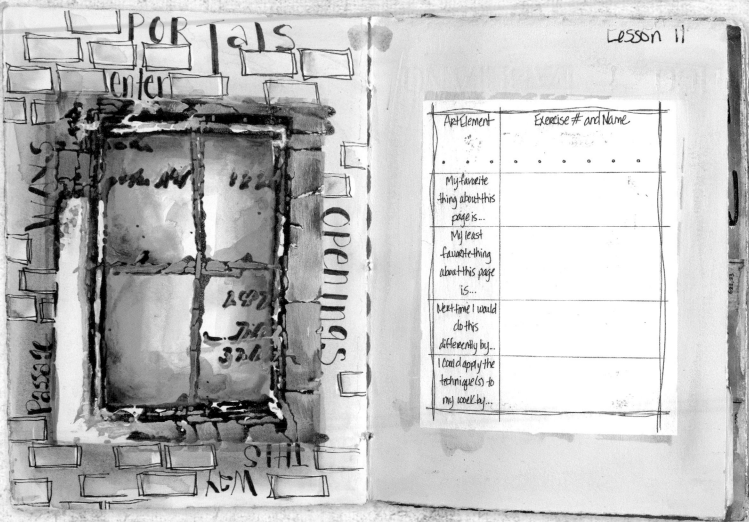

| Art Element | Exercise # and Name |
|---|---|
| • • • • • | • • • • • |
| My favorite thing about this page is... | |
| My least favorite thing about this page is... | |
| Next time I would do this differently by... | |
| I could apply the technique(s) to my work by... | |

Lesson 11

INTENTIONALLY LEFT BLANK

## objective

*To create repetitive shapes in varying sizes to evoke a feeling of unity on the page.*

Using repetitive shapes brings symmetry and a sense of order to your art, even if the shapes are randomly placed. Often, you can identify a shape in a stencil or an image and play off it in various ways to lend cohesiveness to the page. Stencils are great tools with which to emphasize shapes and a great starting point for the journaling process. Try using them with layering in mind, not just as the main focal image. Pay special attention to the shapes at play in your work and use those same shapes in subsequent layers of the journaling process.

## SUPPLIES

Stencil with one main design element

Stencil brush or sponge

Acrylic paints

Heat tool (gun or iron)

Removable painter's tape

Bingo dauber bottle filled with acrylic paint recipe (page 165) in several colors or you can mix a wash of color directly on your paint palette

Brushes

Baby wipe or rag

Markers (optional)

Water-soluble pencils

Black permanent pen

fig. 1

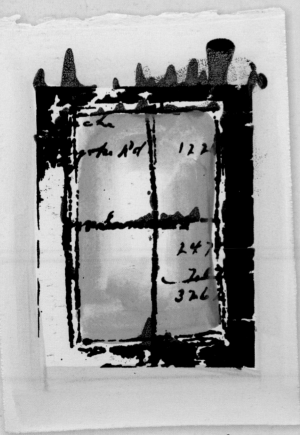

fig. 2

**1** Place the stencil on your page and, with a stencil brush or sponge, pounce acrylic paint onto the design, and then dry with a heat tool. Look for a design that has a repetitive shape in it. I chose a window stencil of my own design; it has a rectangular shape that is echoed in each of the panes as well **(Figure 1)**.

*note* **You can use removable painter's tape to hold the stencil in place if needed.**

*tip*

★ Stencils often feature a repetitive shape. Determine that shape in your stencil design and play off it for the rest of this exercise.

**2** Using a bingo dauber bottle or a light wash (one part paint to three parts water), quickly apply paint to the inside of the stencil design and add a different color to the outside of the design. Move paint around with a wet brush and dry with the heat tool **(Figure 2)**.

3   Add more paint washes both around and inside the stenciled area and use a baby wipe to move the paint around, softening and blending with the first colors. Dry with the heat tool **(Figure 3)**.

4   Incorporate your dominant shape into the background in other ways. Here, I added some rectangular bricks in the background to play off the rectangular shape of the window. Use paint or markers to create the shapes **(Figure 4)**.

5   Add more color around the shapes with water-soluble pencils and activate with a wet brush. Sketch around the shapes using black pen and add journaling as desired.

6   Lay the stencil used in Step 1 over the stenciled image on the page slightly off from the first image and, using a different color of paint with a dry stencil brush, "pounce" some color over the top to finish off the page.

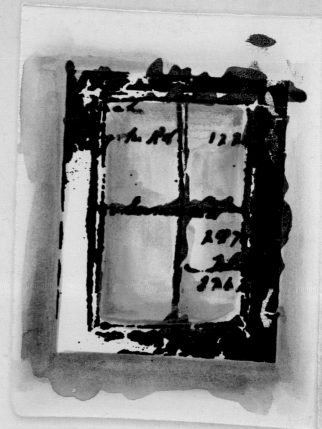

*fig. 3*

# RESULTS MAY VARY

Sometimes I'll get an email from artists frustrated because they don't have the exact tool or media I used when demonstrating a project, and they think they're stuck. That is far from the truth! When you are working in mixed media, one of the more important things to keep in mind is that there are no rules. When you take on a project, don't decide you can't do it based on the list of supplies. Not everyone has access to the same things, and keeping an open mind as to where you can make substitutions is part of the creative process and one of the reasons why many people can follow the instructions to a project and the results are different. Embrace that! It's one of the pleasures of creating and can guide you on a path to some truly original and exciting work. (See pages 165–169 for descriptions of supplies and possible substitutions.)

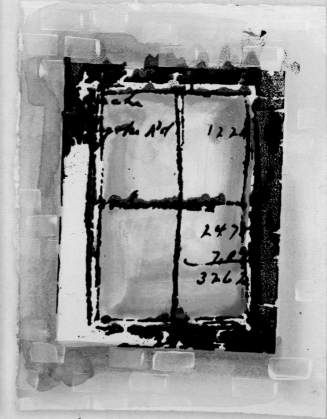

*fig. 4*

# Ephemeral matters

## Lesson 12

| Art Element | Exercise # and Name |
| --- | --- |
| • • • • • • | • • • |
| My favorite thing about this page is... | |
| My least favorite thing about this page is... | |
| Next time I would do this differently by... | |
| I could apply the technique(s) to my work by... | |

**INTENTIONALLY LEFT BLANK**

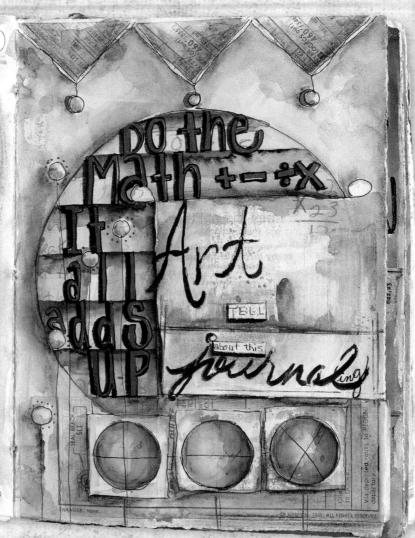

## objective

*To create a collage using random shapes cut from everyday ephemera and add color with media other than paint.*

Artists often can get caught up in searching for old book pages, vintage ledgers, and other ephemera of days gone by to use in their work. Granted, they're beautiful and you can create lovely artwork with them, but there is an unending source of materials that is there for the taking but often overlooked. *Ephemera* is just a fancy word for written and printed matter not intended to be retained or preserved—in other words, about half of what comes in the mail every day! Receipts, children's schoolwork, brochures, and menus, things you'd throw into the trash, paper by-products from work. It's everywhere. So the next time you start to "file" that piece of paper into the trash can you may want to think twice!

## SUPPLIES

Craft punches in various shapes and/or scissors

Everyday ephemera

Mixed Media Adhesive or other collage glue

Gesso

Acrylic paint medium

Brushes

Permanent black pens

Faber-Castell Big Brush Pen (included in Mix & Match Mixed Media Sampler, see note below)

Word stamps (optional)

Gelato or water-soluble crayon, pastel pencil, and water-soluble pencil all in the same neutral color palette

*note* Faber-Castell offers all of these in a Mix & Match Mixed Media Sampler with different color palettes.

Blending stump (optional)

Assorted journaling pens and markers, including a graphite pencil and white gel pen

fig. 1

fig. 2

1   Punch or cut shapes from everyday ephemera: magazines, newspapers, junk mail, old homework, sales receipts, etc. Glue these down directly onto your white page using Mixed Media Adhesive or other collage glue. Keep an eye on pattern as you lay out the shapes. Let the page dry thoroughly **(Figure 1)**.

## tip

★ Don't overlook using the scraps left behind after punching or cutting out shapes. Use the negative-space scraps as well for adding even more interest to the page.

2   Paint a glaze of one part gesso and one part acrylic paint medium to four parts water over the entire page and let dry. This will unify the elements on the page. Once it is dry, you may want to add some undiluted gesso over some of the text to hide it a bit more. Let the page dry completely **(Figure 2)**.

3   Use permanent black pens to outline and draw in details and doodles **(Figure 3)**.

4   Use a Faber-Castell Big Brush Pen to add some lines to the page (as I did in the large circle) and, while the ink is still wet, wash out the lines with a wet brush. The India ink can be manipulated with water while wet and becomes permanent when dry. Use the Big Brush Pen to add some words or to color onto a word stamp and use as ink.

5   Use a water-soluble pencil to color around the shapes to shade them. Wash out the pencil with water **(Figure 4)**.

★ Faber-Castell Aquarelle pencils are waterproof once dry, so you can go over them with other media without smearing. If you use a different type of watercolor pencil, use Mixed Media Adhesive or other type of gel medium mixed with water (one part medium to four parts water) to set the watercolor pencil and make it permanent.

6   Look for words in the text that can be highlighted with a shape drawn around them. It's fun to see what pops up.

7   Use a Gelato or water-soluble crayon to add color to the page. Color directly onto the page and then activate with water for a stronger color, or touch a wet brush to the Gelato and then add to the page for softer color. Let dry.

8   Use the pastel pencil to add soft touches of color to other areas. Here, it was used to color the triangle banner at the top and to help define the three circles on the bottom of the page as well as add soft color around the edges. Blend with your finger or a blending stump.

9   Journal your thoughts onto the page using a Pitt Metallic Pen from the set or other type of marker. Use the lines you created with the Big Brush Pen as easy guidelines for your writing.

## TAKE FIVE

Sometimes when you finish with a page you look at it and feel it needs a little something more. Not sure if you should stop or keep going? Take five (minutes) and come back to look at your work with fresh eyes. Try looking at it upside down or hold it up to a mirror for a different perspective. Even scanning it and looking at it on the computer screen can help you see things you might not have before.

fig. 3

fig. 4

# Cutouts and cutaways

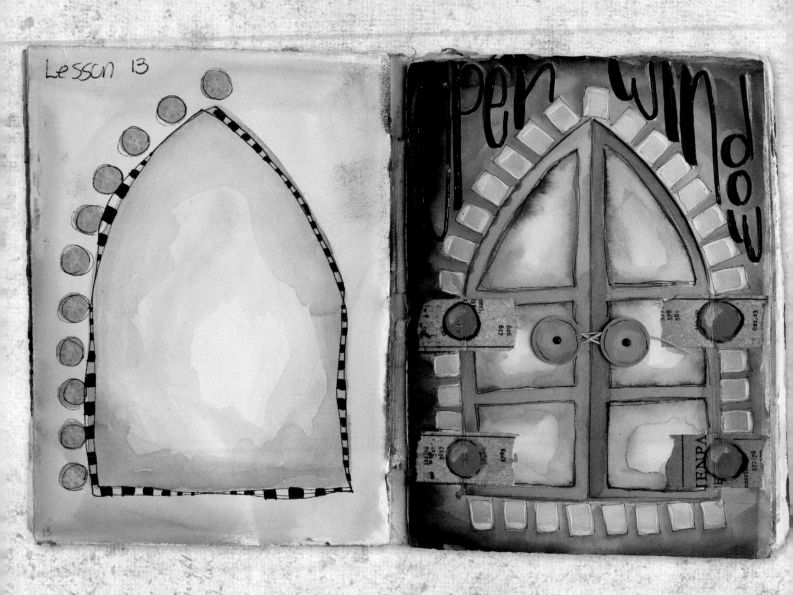

Lesson 13

13

## objective

*To create an interactive journal page that leads to glimpses of other pages.*

~~~~~~~~~~~~~~~~~~~~~~~~~

Creating portals, or openings, on your journal pages lets the viewer get a glimpse of what lies ahead. These openings create a page that looks one way when the portal is closed and still another when it's open. The page becomes interactive, touchable, and changeable. It can create a sense of wonder and anticipation as to what comes next. Visually, it's pleasant to look at, but it also can hold deeper significance, one that is full of possibility, with hidden meaning that has to be exposed by the viewer's hand. By cutting an opening, you are framing the shape on the underlying page.

SUPPLIES

Heavy paper to make a template

Craft knife

Pencil

Washi or other decorative tape

Brushes

Bingo dauber bottle filled with acrylic paint recipe (page 165) or you can mix a wash of color directly on your paint palette

Gesso

Watercolor paints

Acrylic paint

Small scrap of cardstock

Craft punch, small circle shape (or use scissors to cut out shape)

Two small brads

4" (10 cm) piece of string

Permanent black pens

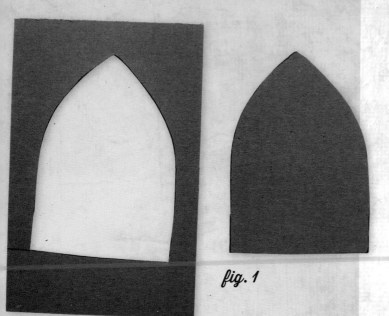

fig. 1

1. Cut a template for a window or door opening out of heavy paper using a craft knife **(Figure 1)**.

2. Trace the shape onto the journal page with a pencil. If you want it to open from both sides, add a midpoint line as well **(Figure 2)**.

note Don't cut out the opening until you're done painting the page. This makes it much easier to work on.

3. Draw shapes inside the door/window with pencil. Add rectangular strips of decorative tape to the places where the door/window will open, kind of like a hinge. Add a circle of paint with the dauber to each of the rectangular hinges **(Figure 3)**.

4. Use a flat brush to add gesso rectangles around the door/window like bricks. Let the gesso dry completely. The gesso will act as a resist when you add paint in the next step.

5. Use a large (¾" [2 cm]) flat brush to add watercolor around the door/window. Go right over the gessoed "bricks." The paint won't completely cover them because the gesso resists the watercolor. Continue to add the first layer of watercolor to the other blocks on the page and let dry **(Figure 4)**.

6. Add more watercolor paints to deepen the painted areas. Allow layers of color to dry between applications.

7. Use a craft knife to cut open the window/door shape. Be careful not to cut all the way around. Fold on the taped "hinge" areas **(Figure 5)**.

8. Paint the back side of the window/door opening with journaling lines using acrylic paint. Paint over the dry acrylic with a watercolor wash. The acrylic paint will resist the watercolor wash so your lines will still show through.

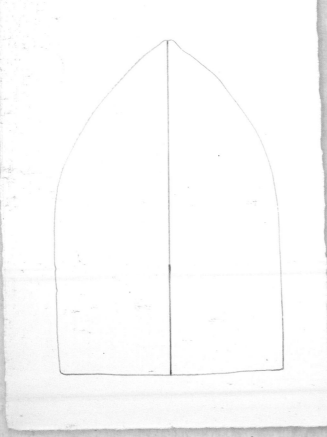

fig. 2

9 To close the window/door you can add two circles cut or punched from cardstock. Make a small hole in the center of each and attach to the page with small brads. Tie a string to one side and then wrap around the opposite side when you want to close the window/door.

10 Use permanent black pens to add finishing details and journaling to the page.

note *You might want to wait until you've finished the page that will be showing through the window (Lesson 14) and then add journaling that incorporates that page.*

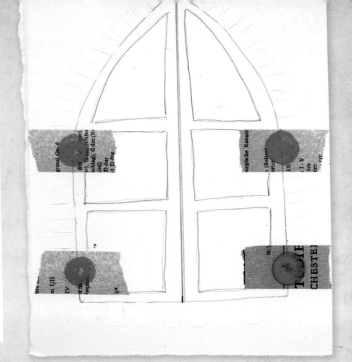

fig. 3

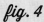

fig. 4

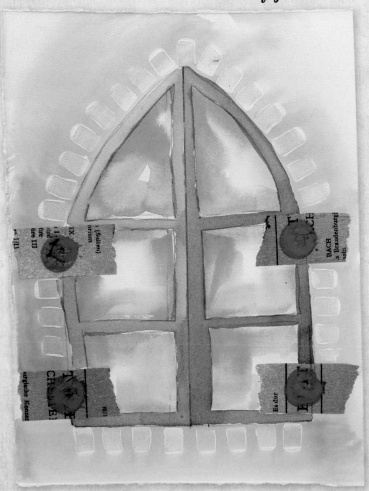

fig. 5

LESSON 14

Building character

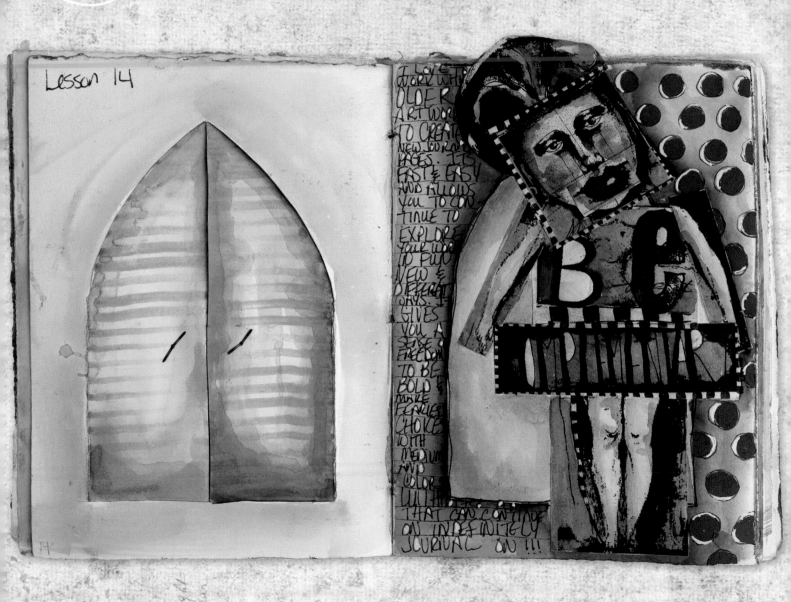

objective

To create a character by collaging shapes cut from previous artwork.

Creating a character using cutout shapes is a lot like playing with paper dolls. You can position them, dress them, add hats, and make other accessories, giving them personality and adding an air of play to your journal-time activities! It's a fun way to reinvent and revisit artwork in a whole new way.

SUPPLIES

Black-and-white copies (printed on regular printer paper) of previous artwork (or substitute magazine images or collage sheets)

Scissors

Graphite pencil

Mixed Media Adhesive or other collage glue

Watercolor paints

Brushes

Black permanent pens

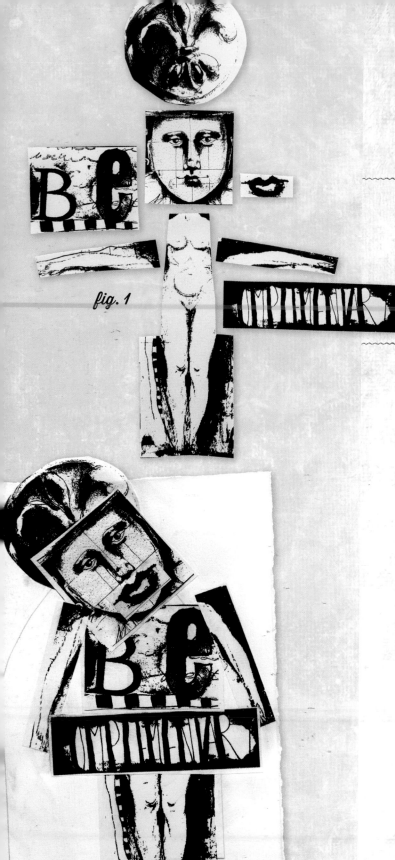

fig. 1

fig. 2

1 Make black-and-white copies of shapes and images from previous work or magazine/collage sheet images. Look for shapes that can be used to create a "character."

tip

★ I like to reuse my previous journal pages to create new pages. This allows me to make fast pages that are uniquely my own. You can substitute images cut from a magazine if you like, but make black-and-white copies of the images with a regular inkjet printer and copy paper.

2 Cut out simple shapes; there is no need to cut around every image, just cut a basic shape around it. Try cutting some of the images apart. Here I cut the arms off of the body so I could create a totally new one **(Figure 1)**.

3 Open up the window/door you created in the previous lesson and trace that cutout onto the current page for Lesson 14 using a pencil. This will help with the placement of your collage so your character will be seen through the open window/door.

4 Lay out the shapes and play with them a bit to find a placement that works on your page.

5 Use Mixed Media Adhesive or other collage glue to adhere the shapes into place. Let dry **(Figure 2)**.

6 Use watercolor paints to block in the different shapes. Be careful not to paint the actual limbs, body, or face. Let dry **(Figure 3)**.

7 Start layering watercolors on top of each other to add depth. Use darker shades of the same colors in the shape blocks. Begin to add some shading to the face and body of your character. Pull the shade colors from the colors already used in the background shapes **(Figure 4)**.

8 Continue adding watercolors to the body until you get the desired look. Using black permanent pens, add designs, doodles, and text to the page.

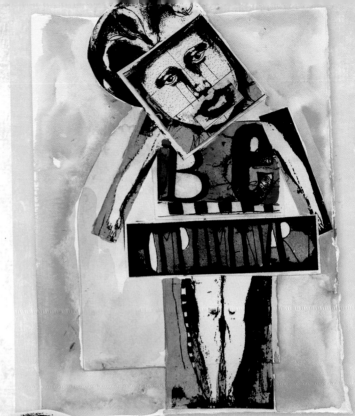

fig. 3

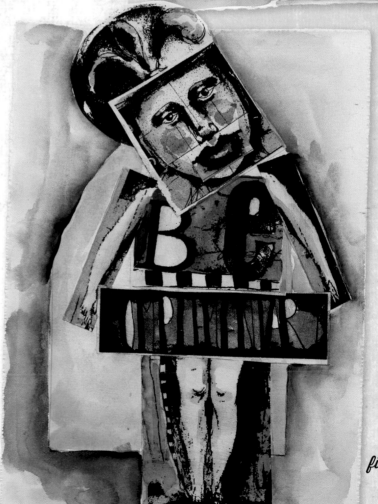

fig. 4

open studio

MARY BETH SHAW

↑ **Glimpse of Eternity**
Acrylic and graphite on canvas

← **Blush of Spring**
Acrylic and graphite on canvas

Balancing on the Head of a Pin →
Acrylic and graphite on canvas

"Never ending, a circle always draws us in.
I find that compositions with circles are
effective when the circles dance across the
page and spill off the edges. I like to see a
variety of sizes in circles and an organic,
not-so-precise quality to their design. I
think these pieces work because they allow
the viewer's eye to move freely around the
canvas in an unpredictable manner."

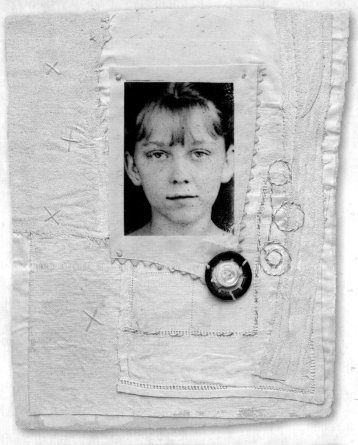

LESLEY RILEY

← **Lost & Found**
Fabric, found objects, and transfers

"There are two primary shapes at work in this piece: the rectangle and the circle. The uneven collage and edges of the rectangular fabric shapes add movement and interest. The contrast, both subtle (threadwork) and bold (buttons and found object), add just enough contrast to take the eye off the focal point (face) of the primary rectangle."

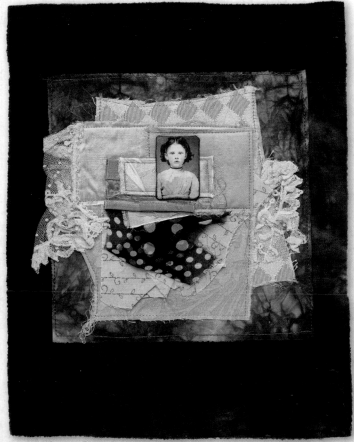

← **Subtle Chance**
Fabric, found objects, and transfers

"This piece is composed of layered rectangles. The folds and uneven edges, in combination with the colors and added dimension of the layering, turn a formal composition into a lively playground for the eye. The texture found in the uneven anchors (lace) on either side of the composition, in combination with the high-contrast black-and-white fabrics, keeps the eye from being locked on the focal point."

Artist Q&A

Which shapes show up in your work most often? Are they intentional, or do they just happen?

SETH APTER Linear shapes (lines, squares, rectangles) reoccur in my work—sometimes intentionally and often unintentionally. I have come to believe that this reflects my need to apply some much-needed order in a world that can be so chaotic.

LISA BEBI I make a big long squiggle across my work at the end of my creations. I'm not sure why I feel compelled to do it. It's almost as though it's my signature, and I only do it as a last and final gesture, sort of like saying, "This is it. I commit to this piece. It's done."

JILL K. BERRY Most recently, circles and houses. The house is my worst trendy overused shape, but I love the symbol and its various meanings, so I add villages and houses. The circles often manifest themselves as compass roses and flowers. They are becoming more frequent and feel less intentional.

CHRIS COZEN Oval and elongated pod shapes are almost always somewhere in my work. It started with circles and then gradually morphed. Pods are so often present in nature, and I constantly collect new ones.

CHRISTY HYDECK Circles. Always circles. I often work intuitively, so much of what I create falls into the happy accident stage. However, when I fine-tune a piece, I often add circles to create movement and pattern.

JANE LAFAZIO Leaves, vines, flowers, pods . . . they just seem to be the first thing that comes out of me.

JULIE PRICHARD I use a lot of straight lines and rectangular shapes in my art. You will rarely find curves or circles. It's all about the angles for me.

RENÉE RICHETTS I seem to use spirals a lot. They can spin in either direction, be flat or elongated. Sometimes they just show up, but I'll admit, I consciously like the shape and throw it into whatever I can.

LESLEY RILEY Circles and rectangles. Intentionally. I like their order amidst all the pattern, image, and text in my work.

JOANNE SHARPE Most of my work is very loose and whimsical. Lines flow from my brush or pen very comfortably and intentionally. I get "in the zone" with organic, free-flowing lines that connect to other shapes, creating nature images, petal-rich florals, and moving wave patterns.

MARY BETH SHAW I am circle obsessed and have done several bodies of work around different manifestations of circles. They have so many meanings for me; I especially like them stacked up totem-like.

DAWN DEVRIES SOKOL Hearts and peace signs show up quite a bit, and yes, they are intentional. Most of the time if I'm stumped about what to do I just start to doodle one of these symbols to get myself going.

DIANA TROUT I am in love with rounded rectangles and rounded squares, really anything with a round corner. I find a teardrop shape coming up often as well. It just seems that my hand likes to make those shapes, so when I sit down to draw they just begin to appear. They become rocks, flowers, petals, and seedpods, and I build them all together to create everything from little houses to figures.

SUSAN TUTTLE Circles, both standing alone and in concentric format, constantly show up both intentionally and by happenstance in my work. For as long as I can remember, I have been drawn to the rhythm of cycles; to their circular nature, which marks the passing of time in a nonlinear way and promises rebirth; and to the comfort I find in their repetition, pattern, and certainty. I recognize that my own life is steeped in cycles, so it is not surprising that circles would frequently appear in my work.

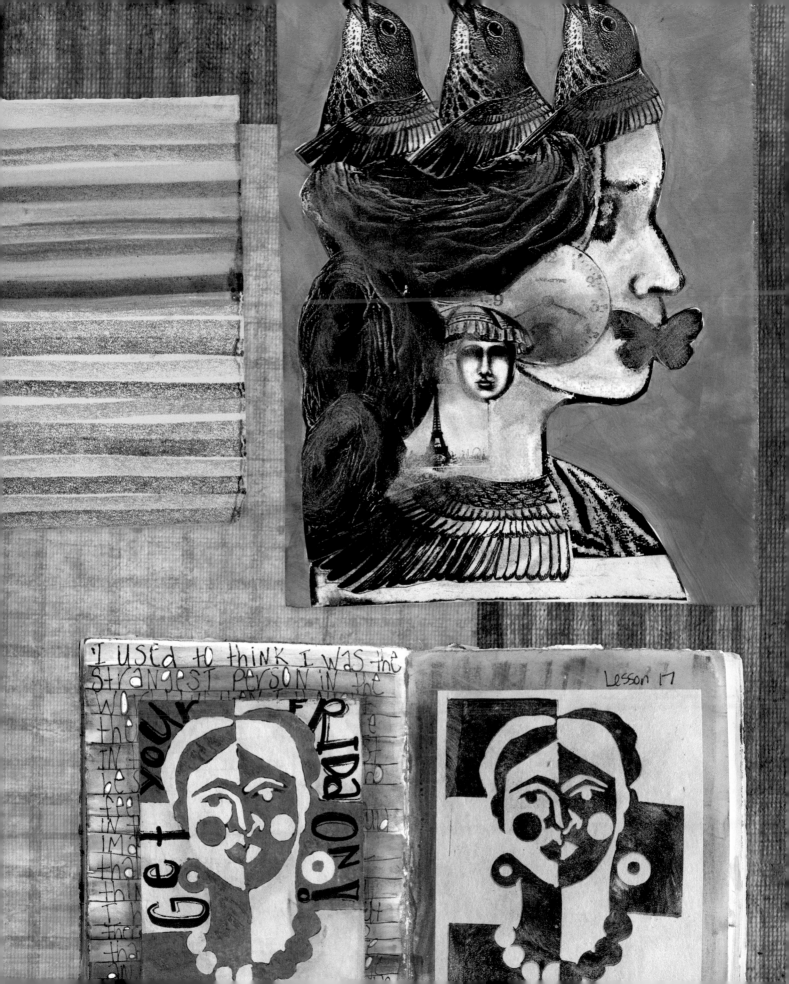

'I used to think I was the
strangest person in the
world

Get your
Friend

only

Lesson 17

sacred space

EXPLORING THE ELEMENT OF VISUAL PERSPECTIVE

Space can be described as positive, negative, personal, shared, open, closed, and in many other ways. **Positive space** is that which is contained within a shape or an object, and **negative space** is everything that surrounds the positive image. In art, both negative and positive space can be used in important and effective ways. By focusing on one or the other, you can evoke very different feelings on your journal pages. In this chapter, we will look at the many roles space plays in the creative process by exploring not only positive and negative space in our work, but also the sacred, personal space inside us and the physical area where we create our art.

QUICK LOOK

| lesson | objective |
|---|---|
| **15** ARCIMBOLDO-STYLE SELF-PORTRAIT | To define positive and negative space by filling one with paint and one with collage. |
| **16** POSITIVELY NEGATIVE | To create two identical images, cut the positive space from the negative space, and then recombine the pieces to create a two-sided image with the positive and negative spaces reversed. |
| **17** CHIP OFF THE OLD BLOCK | To create a positive/negative image and transform it into a carved block to print from. |
| **18** A DIFFERENT VIEW | To look at an object found in your creative space from a new perspective and use it as the focal point for your page. |

LESSON 15

Arcimboldo-style self-portrait

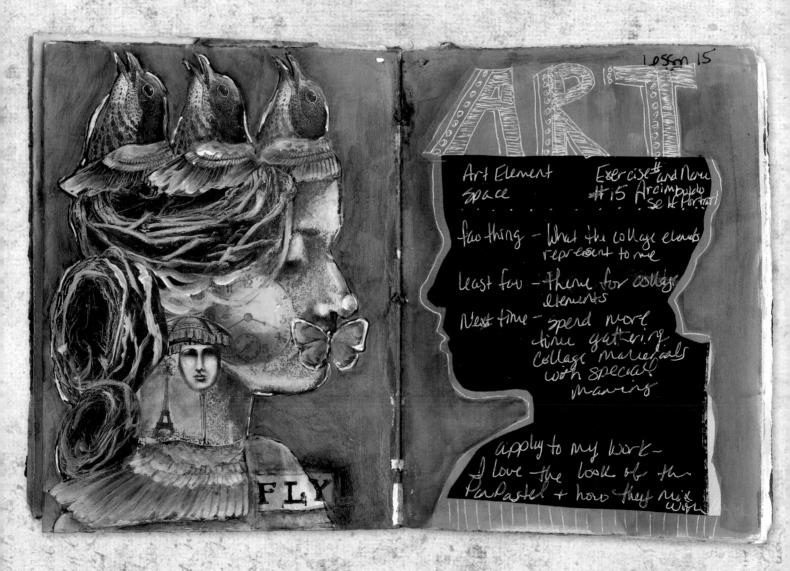

Lesson 15

ART

FLY

Art Element Exercise# and Now
Space #15 Arcimboldo
 Self Portrait

fav thing — what the collage elements
 represent to me

Least fav — theme for collage
 elements

Next time — spend more
 time gathering
 collage materials
 with special
 meaning

apply to my work —
I love the look of the
PanPastel + how they mix
 with

objective

To define positive and negative space by filling one with paint and one with collage.

Nothing is more sacred than the space that is inside of us. It holds everything that is precious and is what defines us and makes us who we are. Creating a self-portrait that reflects our inner self is not as hard as you may think. Inspired by the work of Giuseppe Arcimboldo, we will create a unique self-portrait that focuses on the inside and displays it in the positive space represented in the form of a simple silhouette.

AN ARTIST AHEAD OF HIS TIME

Born in Milan, Italy, Giuseppe Arcimboldo was one of the most bizarre and distinctive painters in history. He lived from 1527 to 1593 and is known for his series of composite portraits of heads made up of a variety of objects. He designed frescoes and windows for a cathedral, had his work presented to Emperor Maximilian II, and designed an elaborate pageant, a coronation, and other state events for Maximilian's son Rudolf II. I encourage you to take a look at Arcimboldo's extraordinary work; I'm sure it will inspire you.

SUPPLIES

Two black-and-white printer copies of a side view photo or drawing of your face

Mixed Media Adhesive or other collage glue (if using other collage glue you will also need clear gesso to topcoat the page after gluing)

Acrylic paint in black and your favorite color

Brushes

Collage images

Scissors or craft knife

Sofft tools

PanPastels in titanium white, buff, burnt sienna tint, Payne's grey, and any other colors you may want for hair and background

Pastel fixative (optional)

Black permanent pen(s)

White gel pen

fig. 1

fig. 2

fig. 3

1 Adhere one black-and-white copy of a side view portrait of yourself to the journal page with Mixed Media Adhesive or other collage glue **(Figure 1)**.

tip

★ Instead of a using a photo or drawing, you can create a silhouette the old-fashioned way by casting your shadow on a wall and having someone else trace it onto a piece of paper for you.

2 Take the second copy, flip it over, and trace the outline of the face on the back (if you can't see it through the paper, hold it in front of a light source like a window). Paint the positive image (inside of your face) with black acrylic paint and let dry. Adhere this to the opposing page of the one you glued the first copy on. It will look like an old-fashioned silhouette and create a nice place to write your assessment of this lesson using a white gel pen **(Figure 2)**.

3 Returning to the first portrait you added to the journal, paint the negative space (everything outside of your face image) with your favorite color of acrylic paint **(Figure 3)**.

4 This is the most time-consuming part of this journal exercise. Pick and choose collage images that represent you and speak about who you are. Lay them out, adjusting the position of the images until you have a layout you like.

5 Adhere the images to the positive space using Mixed Media Adhesive. This adhesive has a ground in it, giving the page a slight "tooth," or texture. If you use another type of collage glue, add a layer of clear gesso to the entire page after the collage work has dried **(Figure 4)**.

6 Using a Sofft tool, begin applying the titanium white PanPastel to the highlight areas on the face. Add just enough PanPastel to color the area but not cover the collage work underneath completely.

fig. 4

PANPASTEL PRIMER

PanPastels are a creamy type of pastel that is applied with a sponge-tipped applicator called a Sofft tool. To load the Sofft tool, just pat it onto the PanPastel three or four times and then onto the areas you want to color. You can blend the colors right on your work just by patting them with the tool. You can also load the tool with more than one color and then blend it directly on your work. If you want to make them more permanent you can spray them with a light coat of pastel fixative after the page is complete. Although you can use other soft pastels, I prefer PanPastels. They have excellent coverage, are easy to apply, and are less messy than traditional stick pastels. They also eliminate the worry of inhaling pastel dust.

7 Continue adding burnt sienna tint Pan-Pastel to the rest of the face. Deepen the shaded areas with a little Payne's grey PanPastel. Add more colors to the hair, clothing, or other elements as desired **(Figure 5)**. Spray with a light coat of pastel fixative when the page is complete.

8 Add more details and journaling with black and white pens.

fig. 5

Positively negative

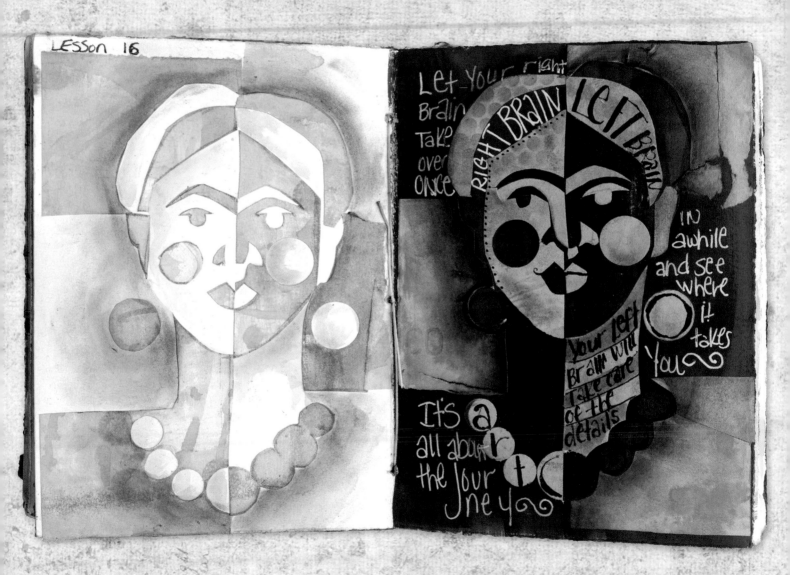

objective

To create two identical images, cut the positive space from the negative space, and then recombine the pieces to create a two-sided image with the positive and negative spaces reversed.

Negative space can most easily be described as anything that is not the focal object. By cutting away the negative space in an image and, instead of throwing it away, using it to create a journal page and allowing the image to appear in the background, you can truly discover the meaning and beauty of negative space and the important visual impact it can have.

SUPPLIES

Acrylic paint in one color for background

Brushes

Image or sketch for design

Tracing paper

Black permanent pen

Graphite pencil

Bone folder or burnishing tool such as a spoon

Decorative paper in a slightly smaller size than journal page (can be handmade or scrapbook type)

Craft knife or scissors

Mixed Media Adhesive or other collage glue (if using other collage glue you will also need clear gesso to topcoat the page after gluing)

Assorted journaling pens

PanPastels or other pastels in colors for shading, such as Payne's grey and Dairylide Yellow Extra Dark (or other dark ochre color)

Sofft tool(s)

fig. 1

fig. 2

fig. 3

fig. 4

1 Paint your journal page in a solid color with acrylic paint. Allow brush-strokes to show for added texture. Let dry **(Figure 1)**.

2 Choose a sketch, photo, or design that has symmetry (is the same on both sides). I chose to use a sketch I made of Frida Kahlo **(Figure 2)**.

3 Place the image under a sheet of tracing paper and, using a black pen, draw a simplified version of it, playing on the shapes within. Draw a line straight down the middle of the sketch, dividing it in two width-wise and dividing up the negative (background) space with a couple of horizontal lines **(Figure 3)**.

4 Turn the tracing paper drawing over and trace all lines with a graph-ite pencil. Place the tracing paper drawing, graphite side down, on top of the painted journal pages and, using a bone folder or the back of a spoon, burnish the graphite lines onto the page **(Figure 4)**.

note *You will have enough material for two pages with this exercise, so if you want, you can glue the leftover cutouts to the opposing page for a mirror image. To get a different look, I decided not to paint the background on the opposing page.*

5 Use the same tracing paper drawing and burnish the graphite lines onto a second piece of decorative paper as well. The second piece of paper can be scrapbook paper or painted paper like I used and should be slightly smaller in size than the journal page **(Figure 5)**.

tip

★ For added interest, try tearing some of the background shapes before gluing them.

6 Begin by cutting the image on the decorative paper in half with a craft knife or scissors. Cut all of the positive shapes out of the right side of the image and glue the positive shapes into place on the sketched outline on your journal page using Mixed Media Adhesive or other collage glue. Do the same with the negative shapes and glue onto the opposing journal page.

7 Cut all of the positive shapes from the remaining side of the image and glue the positive shapes onto the opposing journal page. Glue the negative image onto your main journal page **(Figure 6)**.

8 Add journaling with assorted pens as desired. Use PanPastels with a Sofft tool (or other pastel) to shade around the outside of the image on your journal pages.

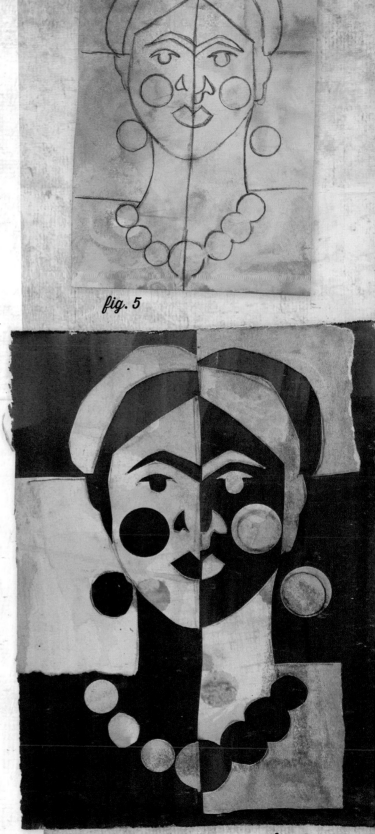

fig. 5

NEGATIVE REINFORCEMENT

Years ago, when I was teaching scrapbook workshops, I often helped people get over their initial fear of cropping a photo by having them cut away the negative space around the focal image and then look at what was cut away. Most often they would see that the negative space was not important to the focal image and would be relieved that they had not cut out something crucial but rather made the focal image stronger. As I moved to mixed-media work, and art journaling in particular, I began to realize the value of using the negative space that is cut away from the focal image. I encourage you to examine both the positive and the negative images you create when cutting out collage materials and to use both in your work.

fig. 6

Chip off the old block

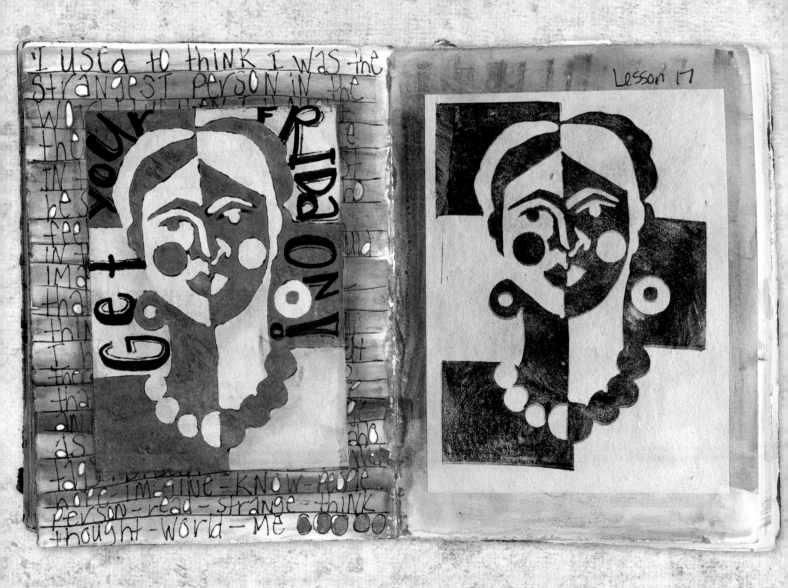

objective

To create a positive/negative image and transform it into a carved block to print from.

Carving print blocks is one of my favorite things to do. It helps me slow down, unwind, and carve away stress as the image reveals itself in the block. Although I mostly carve on linoleum, using a softer material is a great way to make a quick printing block and is user-friendly if you're new to carving. I highly encourage you to give this a try, but you can also use a rubber stamp to complete this exercise if you choose not to give carving a go.

Inktense blocks or other water-soluble colored pencils in three to five colors that blend well together

Brushes

Black permanent pen(s)

Reduced size (4" × 6" [10 × 15 cm]) copy of positive/negative image used in Lesson 16 or a different image

Tracing paper

Graphite pencil

4" × 6" (10 × 15 cm) Safety-Kut or other soft carving block

Bone folder or burnishing tool such as a spoon

Speedball or other type of linoleum-cutting tool with blades

Stamp pad and permanent black ink (for testing carved image)

Newsprint or scratch paper to test the carving

Derivan Block Printing Medium and acrylic paint, or block-printing ink

Acrylic paint in color you want to print with

Bench hook inking plate (optional but recommended)

Soft brayer

Fine-grit sanding block (optional)

Hard brayer or baren

Printmaking paper such as mulberry paper

Mixed Media Adhesive or other collage glue

Journaling pens

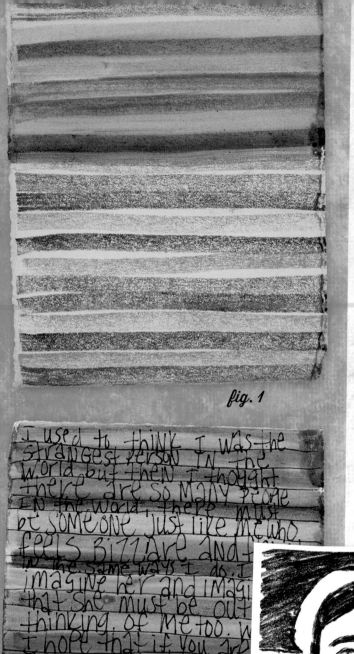

fig. 1

1 Use Inktense blocks or other water-soluble pencils to draw horizontal lines across the page. Use several colors that go together. Activate the Inktense by brushing a wet brush horizontally across the page. Let dry **(Figure 1)**.

note *Once dry, the Inktense becomes permanent, so there is no need to fear adding other wet media on top of it.*

2 Using the permanent black pen, draw freehand lines across the page following the colored stripes laid down in step 1. With a permanent black pen, journal words, a quotation, a poem, or whatever you like on the lines, filling the whole page **(Figure 2)**.

3 Resize the image you used in Lesson 16 to fit a 4" × 6" (10 × 15 cm) carving block or use a different image **(Figure 3)**.

4 Place tracing paper over the resized image and trace it with a graphite pencil. Use the pencil to color in the parts of the image you aren't going to carve away. Use the positive/negative image you made in Lesson 16 as your guide **(Figure 4)**.

fig. 2

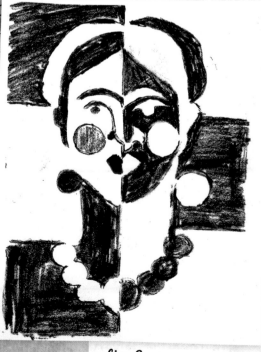

fig. 3

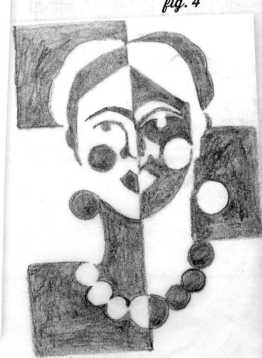

fig. 4

5 Place the tracing paper, pencil side down, on top of the carving block and burnish with a bone folder or spoon to transfer the design to the carving block **(Figure 5)**.

6 Using a #2 large V-blade, cut around all of the lines to create a channel that will help prevent undercutting (making the cut slant under the printing surfaces of the carving, which weakens the carving). The channel will also help prevent cutting into your design as you carve away the negative space **(Figure 6)**.

7 Use the #5 large U-gouge to remove large areas of the negative space around the image, leaving behind only the areas you want to show up in the print. Use the #1 small V-blade to get into tighter areas and the #4 square gouge to clean up any "trails" left by the other carving blades **(Figure 7)**.

tip

★ Sometimes the "trails" are a desired part of the design in a carving, so you may want to make a test print before you carve them away to see whether you want to keep them or not. This also helps you see what the carving looks like on the block, making it easier to see what the final image will look like.

8 Test your carved block by inking it with the stamp pad and stamping onto scrap paper. You'll be able to see whether additional carving is needed.

9 Combine equal parts Derivan Block Printing Medium and acrylic paint or use ready-made ink and spread it out on an inking plate or palette with a soft rubber brayer.

10 Ink the carved print block by rolling the inked-up brayer over it in multiple directions.

note If you have large areas that are left intact on the carving, you may want to rough them up a bit by lightly running a fine-grit sanding block over them. *This will give them "tooth" to better hold the ink.*

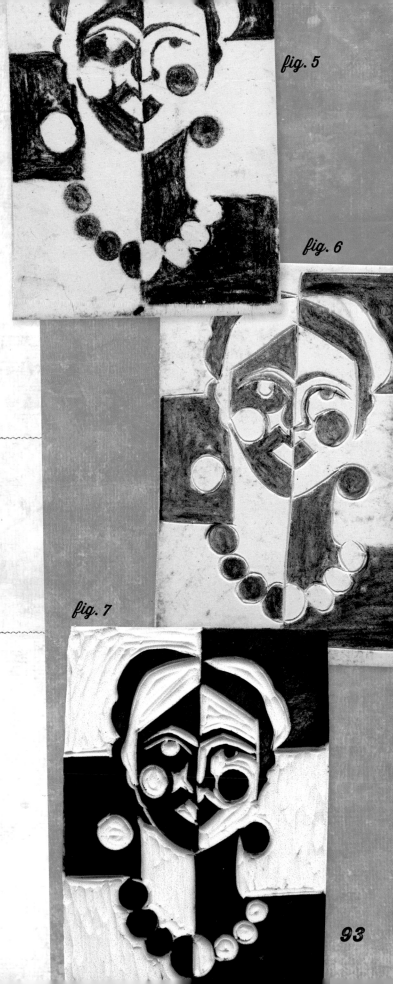

fig. 5

fig. 6

fig. 7

CARVING TOOLS

Carving blocks come in many varieties. If you've not carved before, it's best to start with one of the soft, rubber-like blocks, using a bold design with few details. Once you've become comfortable with the carving process, you can get more detailed and even move on to linoleum blocks, which are harder to carve but allow for more intricate design possibilities. Speedball linoleum cutters come with blades that are stored in the handle. The blades are labeled on the back with a number. Commonly used sizes include:

#1 Small V-Blade Used to outline the design and to help prevent undercutting or cutting into your design

#2 Large V-Blade Used to get into small areas

#3 Small U-Gouge Used for outlining larger, less-detailed images

#4 Square Gouge Used to remove large curved areas

#5 Large U-Gouge Used to remove large areas of negative space quickly

#6 Knife Used to cut large blocks into smaller sizes or to cut around a finished carving

Speedball linoleum cutter with several blades: (from top to bottom) small U-gouge, small V-blade, large V-blade, knife.

CARVING AND PRINTING TIPS

Here are some tips to help you carve and print safely and easily.

★ The blades are replaceable and should not be used when dull because it can increase the risk of injury to both yourself and your work. If you notice the soft carving block tearing as you glide the blade, it's time to replace the blade.

★ Always carve away from yourself! Using a bench hook inking plate will help the carving block remain stable while you carve, and it doubles as an inking plate.

★ Soft brayers are used to apply ink to the carving; hard rubber brayers, or barens, are used to burnish the ink onto the print paper.

★ If you're using a linoleum carving block, you can soften it up by warming it near a heat source such as direct sunlight or a lamp. I love carving outside on a warm sunny day.

11 Do a test print on newsprint, laying the paper on top of the carved block and gently pressing into place. Use the hard rubber brayer or a baren to transfer the ink. Take your time; it may take a few minutes to transfer all of the ink to the paper. Roll in both directions, making sure the paper has good contact with the carving. Once you are happy with the test print, do a print on printmaking paper. Let this dry completely **(Figure 8)**.

tip

★ Don't throw away your test prints! Save them to use on future journal pages or for other collage work. They make great page starters.

12 Trim the dried print if necessary. Apply Mixed Media Adhesive or other collage glue to the back of the print and adhere to the journal page right over the writing. You will be able to see a little of the underwriting through the paper.

13 Touch a wet brush directly to the Inktense or other water-soluble colored pencil and paint directly onto the page. Shade around the print and directly on top of it. Add more journaling and doodles with pens.

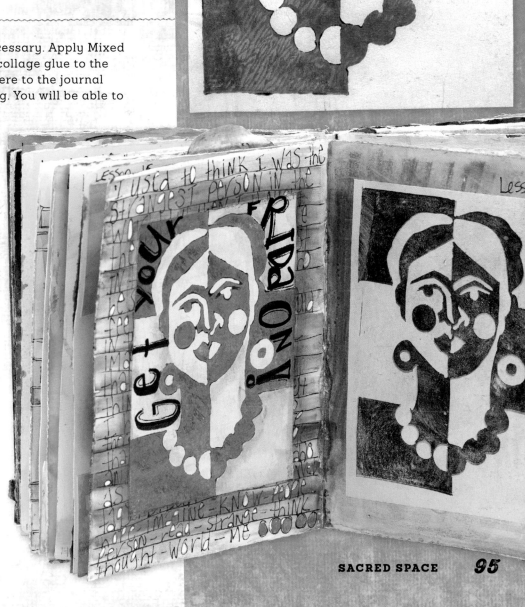

fig. 8

LESSON 18 *A different view*

Lesson 18

| Art Element | Exercise # and Name |
|---|---|
| | |
| My favorite thing about this page is... | |
| My least favorite thing about this page is... | |
| Next time I would do this differently by... | |
| I could apply the technique(s) to my work by... | |

18

INTENTIONALLY LEFT BLANK

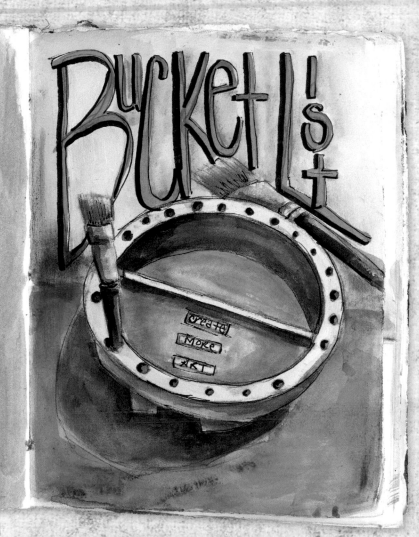

objective

To look at an object found in your creative space from a new perspective and use it as the focal point for your page.

~~~~~~~~~~~~~~~~~~~~~~~~~~~~~~~~~~~~~~~~~~~~~~~~~

It's helpful to look at a subject from more than one perspective. Some things look different when viewed from a fresh angle, and viewing objects from multiple perspectives helps stretch your creative muscles. In this lesson, we'll gain inspiration by looking at the everyday tools and objects we use to create in a new way and making them the focal point of our artwork.

## SUPPLIES

Graphite pencil

Black permanent pen(s)

Bone folder or burnishing tool such as a spoon

Mixed Media Adhesive or clear gesso

Brushes

Sofft tool or other applicator tools

PanPastels in Payne's grey

Kneaded eraser

Acrylic paint in white and one other color

Acrylic paint medium

Painting palette

Inktense blocks or water-soluble colored pencils

White gel pen

fig. 1

1 Choose an ordinary object that you use every day and look at it from its customary angle. Then change your perspective and view the object from a different angle. Try looking at it from directly above or from below, any way that is different than a traditional head-on view, and then make a simple sketch of it on your journal page with graphite pencil **(Figure 1)**.

*tip*

★ You can also take a photo of your subject and create a sketch from it. Just print out a black-and-white copy, and then use a black marker to trace the outline of your subject. Flip it over and, using a light source behind the picture, trace over the black pen outline with a graphite pencil. Place the image pencil side down in your journal and burnish with a bone folder to transfer the pencil lines.

2 Paint Mixed Media Adhesive or clear gesso over the top of the whole page using an X stroke with the brush. This will give "tooth" to the page and allow the PanPastel to grab hold.

3 Use a Sofft tool and Payne's grey PanPastel to shade all of the shadows on your subject. Create lighter and darker areas by varying the pressure used to apply the PanPastel. Pay attention to the spaces that are light and the spaces that are dark and use a kneaded eraser to lift off color if it gets too intense by lightly pouncing with it **(Figure 2)**.

*note* Try starting with the largest shaded areas first, then working your way to the smaller areas. This will allow you to gain better control of the PanPastel as you progress to the detailed areas.

fig. 2

fig. 3

4   Mix one part white acrylic paint with one part
    acrylic paint medium and four parts water to
    create a white wash. Paint the wash right onto
    the Payne's grey PanPastel, turning it into a
    dark shade of blue-gray paint right on the jour-
    nal page. Rinse your brush as needed to keep
    it from getting overly dark and continue to add
    paint to all of the gray areas. Let dry **(Figure 3)**.

5   Add words to the negative space on the page
    with water-soluble colored pencil, then create a
    horizon line across the background with Payne's
    grey PanPastel. Add a thin wash (one part col-
    ored acrylic paint and four parts water) to the
    bottom half of the horizon line. You can also use
    this wash to add a bit of color to your object and
    add words to the page using a small liner brush.
    Let dry **(Figure 4)**.

6   Use Inktense or other water-soluble pencils and
    color the negative space. Activate the water-
    soluble pencil with a wet brush. Let dry and then
    add other details with black and white pens as
    desired.

fig. 4

# open studio

## SUSAN TUTTLE

**C Is for . . .** →
*Digital photo manipulation*

"I consider the element of space both when I frame the photograph in my camera lens and when I manipulate it in Photoshop. In this example, the letter C and my daughter have a symbiotic relationship in space, where they each help define the other (we are in a cupcake shop, "C" is for cupcake, and she is very excited about eating one). I used the Crop Tool to center the C, and both the Clone Stamp and the Healing Brush Tools to get rid of an unwanted coat on the left side of the couch."

## CHRISTY HYDECK

← **Written in the Sky**
*Digital photo manipulation*

"Both in photography and in painting, I find that I often utilize negative space to create a more dynamic and powerful composition. The empty space that surrounds your subject brings a natural sort of balance to a piece and gives the eye a visual place to rest. This allows your focal point to have greater impact on the viewer and can often help create an emotional connection between the viewer and the subject."

# Artist Q & A

## What makes your space sacred?

**SETH APTER** This would have to be a small gift from my mom, who passed away in 2010. It provides me with comfort and a sense that no matter what obstacles may come my way, I can still achieve my goals and dreams.

**LISA BEBI** My art table is sacred to me; however, it's sometimes hard to find under all the "stuff."

**JILL K. BERRY** I have an "altar" table. I set things there that I need to keep in my heart—photos of special people, mementoes, and small treasures from my kids.

**CHRIS COZEN** A photo of my dad, who is my muse.

**JANE LAFAZIO** Besides my kitties . . . my sketchbook.

**JULIE PRICHARD** I don't consider my creative space sacred because the door is always open and anyone of any age is always welcome.

**RENÉE RICHETTS** My "workspace" is wherever I am, mindfully worshiping God by making art. So the most sacred thing there is always God's Light.

**LESLEY RILEY** My most sacred thing is a recent acquisition—a vintage glove maker's mold. It's a creamy colored ceramic open hand that lies flat on my desk, waiting to be filled with ideas, spirit, and art.

**MARY BETH SHAW** I have an altar of meaningful objects and mementoes that inspire me.

**DAWN DEVRIES SOKOL** My collection of pens. I find that I don't like to use them for anything but journaling and doodling. If I have to write a note in my day planner, I will seek out a ballpoint pen even if my journaling pens are right next to me.

**DIANA TROUT** My studio is usually pretty messy with works in progress, painted papers, and, at present, seedpods and stones in little piles every- where. I suppose this controlled "filing system" of mine makes it sacred. There is not another soul who could figure out what is where or why it's there.

**SUSAN TUTTLE** The most sacred thing is an intangible. I would say I have two: openness to the creative process and being adventurous.

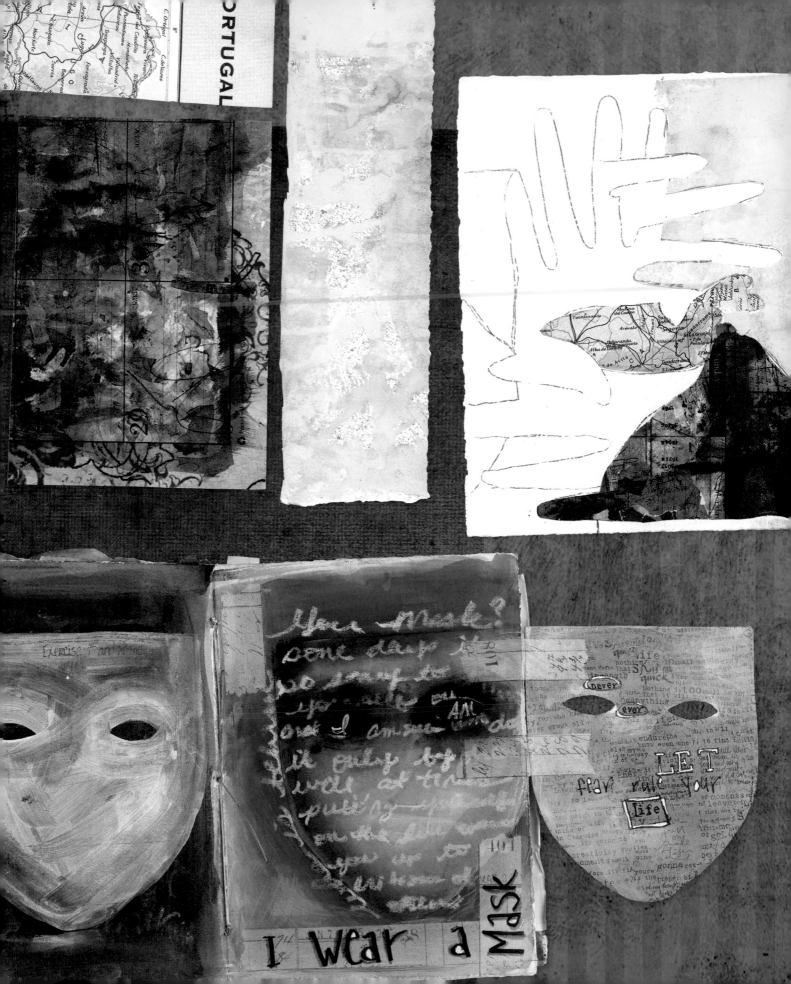

PORTUGAL

I wear a Mask

# the third dimension

## EXPLORING THE ELEMENT OF FORM

Incorporating the element of form into your work is akin to stepping into a movie theater with a pair of cool-looking glasses and watching things jump out at you from the big screen! There are many ways to create form in your artwork. You can build up layers of paper and other materials, attach three-dimensional objects, or create the illusion of form through shading. In this chapter, we'll create actual and implied form through a variety of fun techniques. Using Picasso as inspiration, we'll turn organic shapes into a Cubist composition; morph flat squares, circles, and triangles into cubes, spheres, and cones; create a pop-up page that will take you back to your childhood; and more. So grab your 3D glasses and get ready for action!

## QUICK LOOK

# LESSON 19
# Word search

Lesson 19

Art Element	Exercise # and Name
form	#19 Word Search
My favorite thing about this page is...	I love the simplicity and starkness of this page. It says more with less
My least favorite thing about this page is...	I don't like the way the left side is completely bare.
Next time I would do this differently by...	leave some text showing - i'd add some under·journaling
I could apply the technique(s) to my work by...	I can use this technique in my portraits to add value

## objective

*To bury and then unearth words through layers of collage.*

---

A fun little twist to get your creative juices flowing is to take a sheet of newspaper or other text and then search for meaningful words in it. You can find a voice for your page in a completely different way from using specific cut-out words. Text showing through painted layers is always a great addition to a journal page, and by selecting some words to be left as is and adding a wash of gesso or paint over the others, you will achieve a look that speaks volumes!

## SUPPLIES

Collage papers with text, such as newspaper, old book pages, etc.

Scissors

Mixed Media Adhesive or other collage glue

Water-soluble graphite pencil

Acrylic paint in white

Brush

Black permanent pen

fig. 1

1   Cut two squares, one slightly smaller than the other, out of newspaper, book pages, or other paper that has text on it. Choose the areas you cut so that they each include a word or words that have meaning for you. Using Mixed Media Adhesive or other collage glue, collage the smaller square onto your journal page, then add the larger square on top of the first, positioning it lower and to one side of the first square. Add more paper with text to the background of the page, keeping things simple so that the squares don't get lost on the page **(Figure 1)**.

2   Draw a horizon line with a water-soluble graphite pencil. Use the pencil to draw around key words on the page as well. Trace around the large square and then around the visible portions of the second smaller square. Connect the smaller square to the larger by drawing straight lines from corner to corner **(Figure 2)**.

3   Create a wash of one part white acrylic paint and four parts water. Load a brush with the paint wash and apply it to the water-soluble pencil horizon line to activate it. This will create a gray-toned paint; blend it upward. Rinse the brush and reload it with paint wash as needed to keep the paint from becoming overly dark **(Figure 3)**.

fig. 2

fig. 3

4   Continue adding the paint wash to the back-
    ground below the horizon line. Create a shadow
    from the side of the box by blending out some
    of the pencil the box was drawn with. Add the
    paint wash to the paper at the top of the page
    to blend the background and activate the pencil
    around the words you outlined **(Figure 4)**.

5   Use a wet brush to activate the water-soluble
    pencil inside the box you created. Keep things
    transparent so you can still read the text.
    Continue to activate the pencil on the side
    of the box.

6   Add outline details with a permanent black pen.

fig. 4

# Cubist cutouts

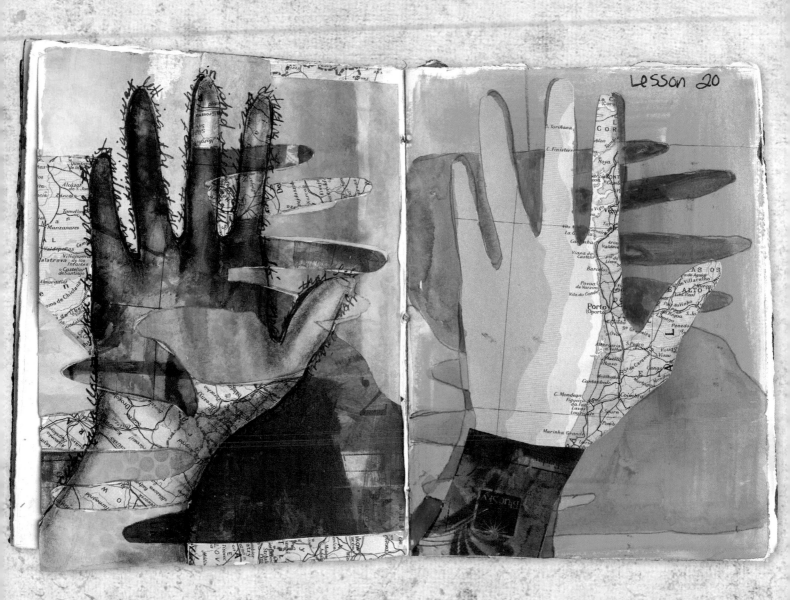

## objective

*To create a page filled with shapes representative of the Cubist style.*

Cubism was a truly revolutionary style of modern art developed by Pablo Picasso and Georges Braque in the early twentieth century. Their aim was to visually express the modern world through their art. In this lesson we will explore Cubism by using our hands as the subject, first dividing them into organic shapes, then disassembling them and finally reassembling them into a finished *papier-collé* collage of painted papers that is representational and not necessarily realistic.

## CUT AND PASTE

**Papier-collé** literally translates as "pasted" or "stuck" paper. It's a technique much like collage, except that flat materials (such as paper, cloth, or tissue) are precisely cut to form objects within a painting instead of overlapping one another as in traditional collage.

## SUPPLIES

Scrap paper

Acrylic paint

Brushes

Ephemera, such as scrapbook papers, maps, or book pages (optional)

Pencil

Two or three sheets of plain printer-type paper

Tracing paper

Eraser

Bone folder

Scissors

Mixed Media Adhesive or other collage glue and clear gesso

Charcoal pencil

Blending stump

Black permanent pen

fig. 1

fig. 2

**1** Begin by lightly painting textures and patterns on the pieces of scrap paper with acrylic paint. You can use the pieces of ephemera as is or paint them as well **(Figure 1)**.

## tip

★ Lightweight paper can curl when painted, but it will stick flat when glued down properly. You can also lay heavy books on your pages overnight to make them flat.

**2** Trace around your hand with a pencil onto white printer paper **(Figure 2)**.

**3** If necessary, resize the tracing on your printer so that it easily fits onto your journal page.

**4** Lay a piece of tracing paper over the hand template and, using a pencil, trace the hand three times, each in a different direction so that the lines overlap to create an interesting representation of your hand **(Figure 3)**.

**5** Use an eraser to go back over the design and erase some of the intersecting lines and add some others to create overlapping shapes. Remember that you will be cutting these out, so try to avoid having very small shapes **(Figure 4)**.

**6** Lay the tracing paper template onto your journal page and burnish the pattern onto the page, using a bone folder to transfer the image. This will serve as your placement guidelines for the next step.

**7** Using the bone folder, burnish the shapes from the tracing paper template onto the painted collage papers from Step 1. Cut out all shapes and lay them on the corresponding guidelines marked on the journal page.

**8** Glue the cutouts into place using Mixed Media Adhesive or other collage glue. Add a layer of adhesive over the top of the cutouts as well, making sure that all the edges are securely adhered. Let dry **(Figure 5)**.

**9** Lay the original hand tracing pencil side down onto the page over the top of the **collé** work and transfer by burnishing with a bone folder. Trace around the outline with a charcoal pencil and blend the charcoal inward using a blending stump. Add journaling around the hand with a black permanent pen.

fig. 3

fig. 4

fig. 5

# LESSON 21

# Pop-up pages

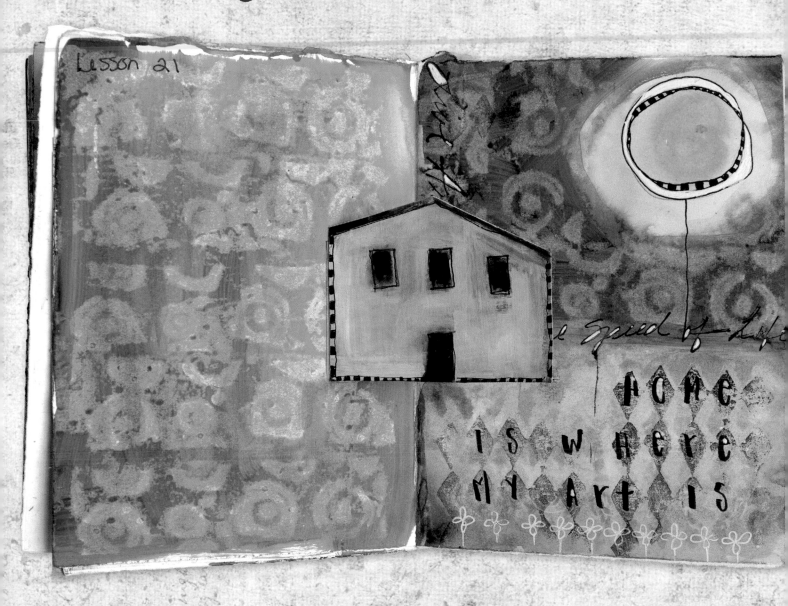

Lesson 21

HOME IS WHERE MY ART IS

## objective

*To create a page that turns two-dimensional into three-dimensional.*

~~~~~~~~~~~~~~~~~~~~~~~~~~~~~~~~~~~~~~~~~~~~~~~~~~~~

Remember how fun pop-up books were as a child? You could look at them over and over, even when you knew every image that would pop out at you by heart. In this lesson, we're going to create a simple pop-up page. Creating pop-up pages turns your journaling in a more interactive direction, and the possibilities are endless for adding 3D punch to your pages. This simple technique can also become quite elaborate if you choose to expand upon it by creating multiple images popping out from one page; either way, it's sure to bring a smile to your face every time you open your journal.

SUPPLIES

Sheet of 90 lb watercolor paper (or same paper you used to make your journal)

Bone folder

Ruler

Pencil

Scissors

Double-sided tape

Assorted acrylic paints or bingo dauber bottles filled with acrylic paint recipe (page 165)

Brushes (if not using bingo dauber bottles)

Baby wipes

Rubber stamps (bold designs work best)

Image for pop-up (optional)

Heavy cardstock (optional)

Journaling pens

fig. 1

fig. 2

fig. 3

1. Cut or tear a piece of watercolor paper to 11" × 7" (28 × 18 cm) or to the size of your open journal. Fold it in half and score with a bone folder.

2. On the fold, use a ruler to mark approximately 2½" (6.5 cm) in from each end with a pencil. From these marks, draw equal lines of about 1½" (3.8 cm) toward the folded paper opening **(Figure 1)**.

note **You can make the lines any length you choose as long as they are equal.**

3. Cut on the drawn lines with scissors. Fold the cut section back and score with the bone folder **(Figure 2)**.

4. Put the cut section back into its original position and open the folded paper like a tent. Push the cut section through to the other side so it folds inward from the spine fold. Close the page and score the folds again **(Figure 3)**.

5. Use the double-sided tape to adhere the folded pop-up page to the inside of the journal.

6. Begin by painting the background using one part acrylic paint mixed with three parts water or the bingo dauber bottles. To create texture, lay a baby wipe on the still-wet acrylic paint and press a stamp onto the wipe. Lift up the wipe and let the design dry. The wipe will absorb the paint from the stamped image, leaving a ghost-like print behind. You can go over this texture with other paint colors once it's dry, and the texture will still show through **(Figure 4)**.

7. Draw, paint, or find a focal image you want to have pop out of the page **(Figure 5)**. Adhere it to watercolor paper or heavy cardstock and cut out. Use double-sided tape to tape it to the pop-up section. Align the image so that the journal will close when it is in place. You will only adhere it to half of the pop-up section; do not tape over the fold.

8. Continue to add paint and journaling as desired.

fig. 5

fig. 4

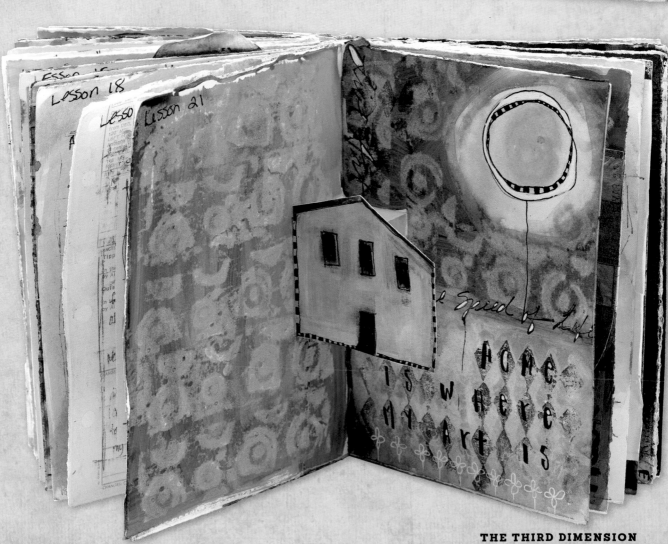

LESSON 22
Behind the mask

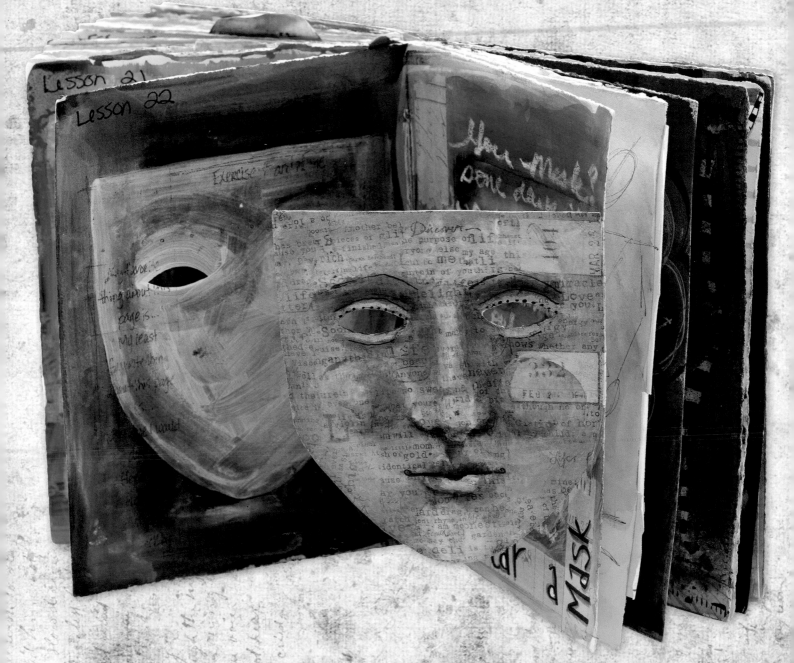

creating ART AT THE SPEED OF LIFE

objective

To create a mask that both conceals and reveals our inner thoughts and feelings.

For this lesson it's time to dig a little deeper to discover what's behind our own masks. Often what is seen by the world is not what is truly going on inside of us. We create a mask that protects both ourselves and those who view it from all that is within. Creating a journal page that depicts us by what we present to the world, and then adding one word of who is really behind the mask, can speak volumes about who and where we are in this life journey.

SUPPLIES

Tracing paper

Permanent black pens

Pencil

Chipboard or other cardboard

Bone folder

Scissors

Craft knife

Palette knife

Homemade paper clay (see recipe below) or purchased paper clay

Tissue paper (decorative or plain), newspaper, or other thin paper

Mixed Media Adhesive or other collage glue

Brushes

Translucent crayon (from an egg-coloring kit or craft store)

Watercolor paints

Tape (masking, decorative, or cloth type), approximately 8" (20.5 cm)

White acrylic paint

HOMEMADE PAPER CLAY

You will need:

Approximately ten squares of double-ply toilet tissue, shredded

1 tablespoon (15 ml) Mixed Media Adhesive or other collage glue

¼ cup (60 ml) water

Plastic zip-top bag, sandwich sized

Place all of the ingredients into the plastic bag and seal shut. Knead the contents in the bag for several minutes until the mixture forms a smooth consistency. Open a small section of the zip opening and squeeze excess moisture from the bag. Store the clay in the closed bag between uses.

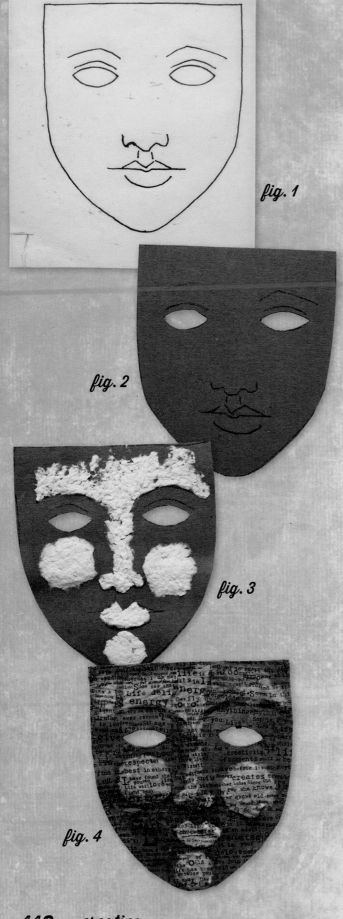

fig. 1

fig. 2

fig. 3

fig. 4

1 Draw a simple mask on a piece of tracing paper. Turn it over and use a pencil to trace over the lines. Place the tracing paper onto a piece of chipboard or other cardboard pencil-side down and burnish the lines with a bone folder to transfer the design **(Figure 1)**.

2 Cut out the mask with scissors and use a craft knife to cut out the eye openings. Use this to trace the outlines of the mask onto your journal page, lining up the side with the edge of the page for later attachment **(Figure 2)**.

3 With a palette knife, start to add paper clay to areas of the face that should be raised. They don't have to be raised a lot, but give them some definition by building them up. Use your fingers to smooth the edges into the flat areas of the mask **(Figure 3)**. Let dry thoroughly (possibly overnight).

4 Cut or tear tissue paper or other thin paper into small pieces and glue with Mixed Media Adhesive or other collage glue in an overlapping papier mâché fashion over the mask. You can apply the Mixed Media Adhesive with a brush; simply add the adhesive to the back of the paper, lay the paper on the mask, apply the adhesive to the top, and then smooth the paper with the brush and your fingers. Cover the back side in the same fashion and let dry **(Figure 4)**.

5 While you're waiting for the paper clay to dry, add journaling and details to the journal page. Inside the mask area concentrate on the thoughts and feelings people don't see—and, using a translucent crayon, write out these thoughts or words. Add more words around the outside of the mask tracing as well. Pay attention to the words that are on the eyes, because these will show through the mask.

6 With watercolor paint, paint over the inside of the mask area, allowing the watercolor to bleed outside of the mask tracing and onto the background. I like to use colors that reflect my mood at the time I'm working on this exercise **(Figure 5)**.

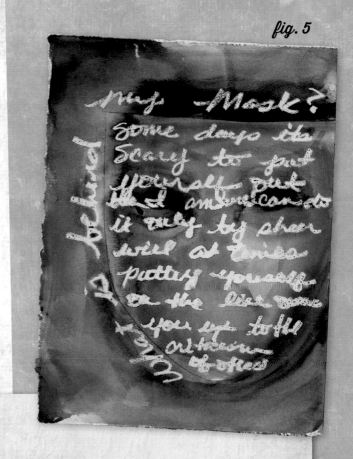

fig. 5

7 Use tape to create a hinge for attaching the mask to the page on the outside edge. Place two 2" (5 cm) pieces of tape half onto the front of the mask and half onto the back of the journal page (so they wrap around to the next spread) and two in the same positions onto the inside of the mask and onto the journal page.

8 Using a wash of one part white acrylic paint to four parts water, paint over the front and back of the mask. Wipe paint from any words you want to show through. Use watercolor paints to shade around facial features on the mask as desired.

9 Add words as desired to the mask and the page. Highlight words with circles or boxes and add other details using permanent black pens.

MASK OF COURAGE

Right before Christmas of 2010, I received one of those phone calls that changes your whole focus in a matter of minutes. My dad had cancer. Again. They wanted to operate immediately.

I am blessed with a wonderful father whose love I've never doubted. I was cared for, loved, made to feel special, and I always had my dad to turn to when life got rough. Now it was my dad who would need to turn to my siblings and me. This was and is very hard for him. He's a hero, a firefighter, someone who takes care of others and relies on his strength and intelligence to get him through hard times and difficult situations. He's a young sixty-something and very active in an outdoorsy way. He'd already survived cancer, twice, and then helped my stepmom battle breast cancer. Now he was being told he had cancer in his face as a result of the treatment from his first battle, twenty years before. It wasn't fair.

One of the many lessons we learn and keep learning in life is that it's not fair. Bad things happen to good people. My dad is "good people." It was evident by all the emails that flooded his hospital website page that I'm not alone in this opinion. Every time (and I mean every time) any of us kids has ever needed help, we knew we could count on him. Now it was time to help him, and he wouldn't, he couldn't, ask. He tried to put on a brave face, a mask that would protect us from the fear he was facing, even though all of us could see through it. We were scared, and so was he. My dad does not cry, and he cried.

He had to wear a mask during his radiation treatment that literally strapped him to the table so he couldn't move. When I think of that mask, I think of the way he felt—scared, fearful, in pain—on the inside of it, and what we saw—bravery, courage, determination—on the outside. Masks hide what's underneath.

open studio

SETH APTER

"Much of my work, including **Disarmed** and **Handiwork**, involves the use of found and altered objects. For me, the addition of dimensional elements onto the flat plane of paper, canvas, or board automatically leads to the creation of a dynamic, tactile, and intriguing surface. This is the essence and the magic of mixed media. It allows the viewer to enter the artwork and be taken on a journey, the experience of which differs depending on the angle at which the artwork is seen. The placement of the elements is critical in any assemblage, and in these pieces choices were made to guide the viewer's eye around and deeper into the many literal and figurative layers."

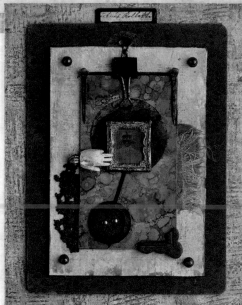

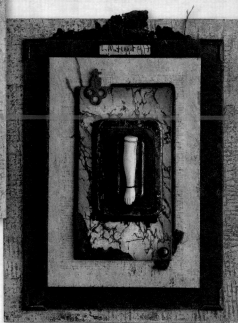

Disarmed
Found objects, metal, paints, papers on wood panel

Handiwork
Found objects, metal, paints, papers on wood panel

RENÉE RICHETTS

Sock Monkey Orbits the World →
Found metal objects, wire, hardware

"The trickiest part about making dimensional mixed-media hinged metal books isn't the book's construction, as one might expect, but rather its 'de-construction.' I approach all my hinged metal books with thematic ideas in mind and initially over-build them to a staggering degree. Then, like any good book editor, I edit—like crazy. **Sock Monkey Orbits the World** was no exception. To get to this final draft, I focused (eventually) on the key theme I wanted in the book: the idea of a monkey in outer space, and what the monkey would eat, and how. Any embellishments that I could not tie into that theme were then removed. Fly, Sock Monkey, fly!"

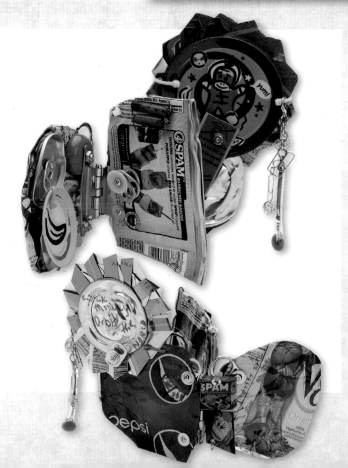

How do you add depth to your work?

SETH APTER Depth for me is all about actual, physical layering. Of color, of paper, of fabric, of metal, of text, of objects. Really, of anything and everything.

LISA BEBI I show depth by the use of overlapping colors—but only a few colors with just a tiny variation of darker/lighter hues. I prefer not to show too much depth. It's my goal to have the subject matter understood to be in its own unique environment.

JILL K. BERRY My work often includes many layers of paint and paper with added shadows to imply even more layers.

CHRIS COZEN Paint and paint glazes are at the top of the list and can provide both subtle and dramatic depth. Acrylic textural products are endlessly variable sources as well, whether you take them straight from the containers or mix up your own concoctions. Then there is always collage and layering of papers. I can easily do all three in one piece.

JANE LAFAZIO The depth in my work is usually done with multiple layers of fabric.

JULIE PRICHARD I let the painting dictate what comes next. If I am in the mood, I will add in layers of art papers or medium. If I am working without too much texture, glazing is my best friend.

LESLEY RILEY There's always depth in my work, typically layers of paper and fabric, usually texture, and often objects.

MARY BETH SHAW Any kind of depth is interesting to me, but at this point in time, I enjoy layering actual items into more three-dimensional paintings.

DAWN DEVRIES SOKOL Usually it's layers, but lately I've been working on using more realistic shadows with pencil to create depth in my street-style lettering.

DIANA TROUT I use shading with values in my work to cast shadows and create volume. I use anything that will get the job done. In my stitched work, I use different colors of threads, markers, pencil, whatever comes to hand.

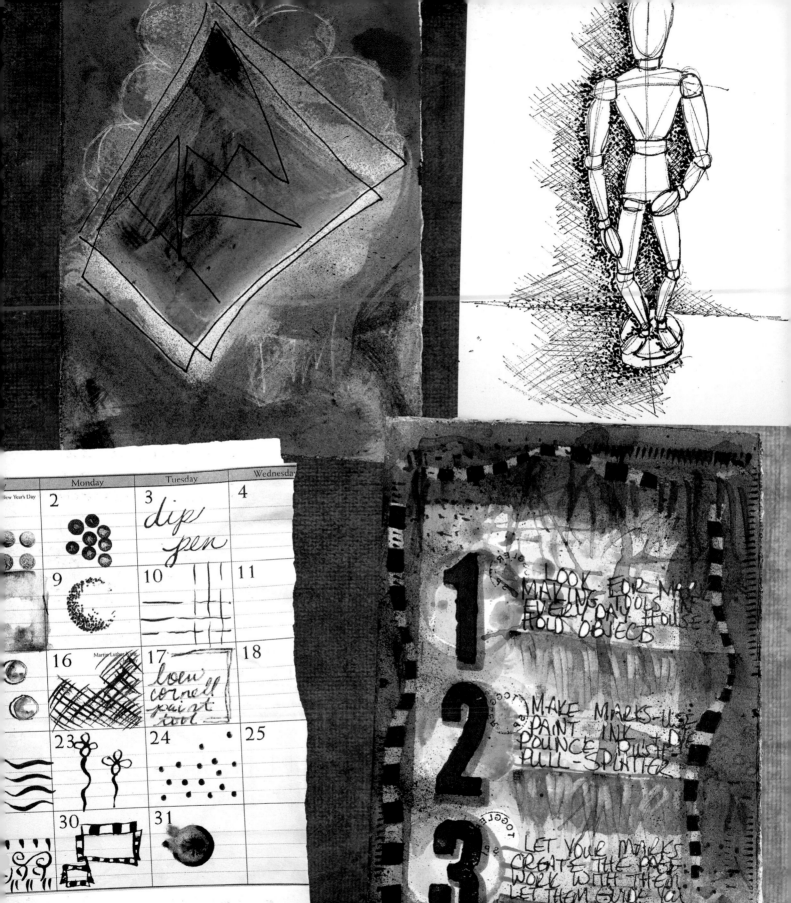

dip
pen

loew
cornell
paint
tool

1 LOOK FOR MARK
MAKING TOOLS-
EVERYDAY/HOUSE
HOLD OBJECTS

2 MAKE MARKS-USE
PAINT INK OR
POUNCE-PUSH-
PULL-SPLATTER

3 LET YOUR MARKS
CREATE THE ART
WORK WITH THEM
LET THEM GUIDE YOU

making your mark

EXPLORING THE ELEMENT OF LINE

For many of us, leaving our "mark" in the form of our artwork is a driving force in our creative being. It's the evidence that we were here, that we had passion, and that we shared in a movement that was ever growing and ever changing. Marks in the form of our journals, sketchbooks, body of work, and the way we communicate visually make up our journey as artists. Making your mark (literally and figuratively) is what the artistic journey is all about. Through the series of lessons in this chapter, we'll explore various tools and techniques used for making marks on the page. These lessons simply provide a jumping-off point, and substituting with tools you already have is greatly encouraged. Look around your workspace, around your home, and elsewhere to find interesting tools to make your mark.

QUICK LOOK

| lesson | objective |
|--------|-----------|
| **23** FINDING YOUR MARK | To explore marks you already make and document them in your journal. |
| **24** GRAND GESTURES | To quickly capture the "essence" of an object in a gesture drawing. |
| **25** URBAN STREET ART | To create your own "tag," or mark, in an urban graffiti style. |
| **26** ART ON A SHOESTRING | To use ordinary items from around the house as mark-making tools. |

Finding your mark

Lesson 23

| | Thursday | Friday | Saturday |
|---|---|---|---|
| | 3 | 4 | 5 |

| Art Element | Exercise # and Name |
|---|---|
| • • • • | • • • • • |
| My favorite thing about this page is.... | |
| My least favorite thing about this page is... | |
| Next time I would do this differently by... | |
| I could apply the technique(s) to my work by... | |

© BlueSky The Color of Imagination, LLC www.blueskyimg.com

INTENTIONALLY LEFT BLANK

objective

To explore marks you already make and document them in your journal.

If you've been creating art for any length of time, you most likely already have defining marks you use in your work. And even if this is the first art journal you've ever worked in, you now have many pages to go back to and look for various marks you've already made. It's interesting to see what shows up repeatedly when you look back at your work. Maybe you tend to make circle marks, or broken lines, or you like to do stripes; whatever you find, it's all part of the evidence that you were here! By finding those marks and documenting them with different media and tools in this exercise, you'll create a reference page to look back on as you move forward in your work.

SUPPLIES

Old calendar page, cut to size of journal

Mixed Media Adhesive or other collage glue and clear gesso

Regular No. 2 pencil with eraser end

Loew-Cornell Berry Maker or other mark-making tool

Empty bingo dauber bottle

Derivan Liquid Pencil Sketching Ink (permanent and rewettable) or other ink

Rubbing alcohol

Loew-Cornell Fine Line Painting Pen

Brush

Dip pen with flexible-tip nib

Black permanent pen(s)

Water-soluble colored pencils

fig. 1

1 Adhere the old calendar page to the journal page with Mixed Media Adhesive and let dry. If you use other collage glue, it's helpful to add a coat of clear gesso to the top of it so the water-soluble media (applied in later steps) will stick **(Figure 1)**.

2 Use the pencil eraser, the Berry Maker, the bingo dauber bottle tip, and the applicator tip from the Sketching Ink bottle dipped into the Liquid Pencil Sketching Ink to create marks in individual calendar squares. Drip a drop of rubbing alcohol into the center of the dauber bottle mark to cause the ink to move away from the rubbing alcohol, creating an organic circle **(Figure 2)**.

3 Use a brush dipped in Liquid Pencil Sketching Ink to shade in a box, moving the ink away from the edges with a wet brush. Fill the Loew-Cornell Painting Tool with Sketching Ink and try stippling (shading by making dots), doodling, and writing on the page **(Figure 3)**.

fig. 3

fig. 2

fig. 4

4 Dip a dip pen into the Sketching Ink and make more marks and doodles. Try cross-hatching, drawing broken lines, and creating lines of varying widths by increasing the pressure on the pen tip **(Figure 4)**.

5 Use a permanent black pen to add notes about the tools and techniques used in each square.

6 Add water-soluble colored pencil to the squares and activate with water to finish the page.

LESSON 24

Grand gestures

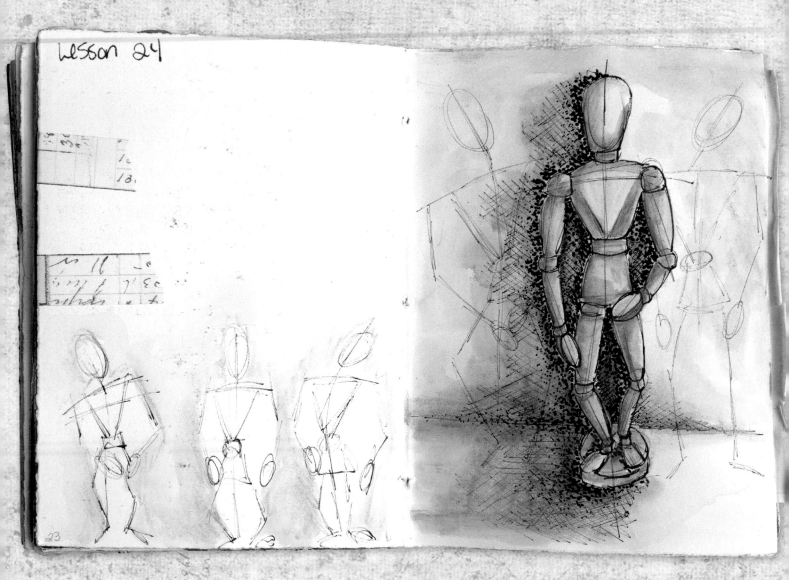

Lesson 24

23

objective

To quickly capture the "essence" of an object in a gesture drawing.

SUPPLIES

Everyday object to sketch

Black permanent pens with various nib sizes

Water-soluble colored pencils

Brush

A wooden artist's mannequin that sits on my art table provides a quick subject to position for this type of drawing. Often gesture drawing is associated with drawing the human figure, but the subject you choose to draw can be just about anything with an "essence" you want to capture. At first, it's probably a good idea to sketch stationary objects or people, but as you gain confidence you should also try "action drawing"—sketching things or people that are in motion. Both gesture and action drawings are made with quick, fluid, minimalistic lines, but while action drawing focuses on the motion of the subject, gesture drawing aims to capture a sense of emotion.

QUICK DRAW

There are several different quick-drawing exercises that will help you find and develop your drawing skills and style. You can practice them anywhere—all you need is a scrap of paper and a pencil or pen.

Gesture Drawing A quick sketch using minimal lines to convey the essence of a subject.

Action Drawing A quick capture of the movement or energy of a subject.

Contour Drawing A simple outline sketch of the subject with no shading—think coloring book art.

Blind Contour A contour drawing made without looking at the paper while you draw. Your eyes should stay focused on the subject the whole time.

fig. 1

1 Choose a subject to draw; something simple with easily identifiable shapes works well. For this exercise, I like to draw an object from the immediate surroundings that I see every day.

2 Use a fine-tipped permanent pen to quickly draw lines that represent the subject. Don't overthink this step; just quickly capture the object's position. Draw lightly with quick, sketchy marks, keeping the pen in constant motion **(Figure 1)**.

3 Add shapes to begin filling in the mass of the subject. Use basic shapes like circles, triangles, ovals, and squares. Continue to work quickly and lightly so you can make adjustments as you move forward with the sketch **(Figure 2)**.

4 Continue to make sketchy marks with the pen. Add rough outlines to the whole sketch **(Figure 3)**.

fig. 2

fig. 3

fig. 4

5 Darken the lines to define the shape of your subject **(Figure 4)**.

6 Use various black permanent pens to add shading with cross-hatching and stippling (see "Shading Styles" on page 147; **Figure 5**).

7 Use water-soluble colored pencils to add color to the drawing and background. Activate the pencil with a wet brush. Let dry.

8 Add journaling with permanent black pens if desired.

fig. 5

A SIMPLE GESTURE

It's fun and helpful to keep a sketchbook just for doing quick sketches. Here are some tips and guidelines for creating quick gesture, action, and contour drawings.

Set a time limit It's important to remember that these are "quick-capture" sketches that shouldn't take more than a few minutes. Try 30 seconds to 2 minutes and document the time used right on your sketch.

Focus on your subject Don't just glance at your subject. Spend more time looking at your subject than at your sketch. It's hard not to look at your drawing, but try to resist the temptation during this exercise.

Stay in line Imagine you can only use one or two lines to capture your subject. Try to convey your subject's essence or action with just these simple lines.

Block it out Sometimes it's helpful to block in shapes such as circles and squares to represent the mass of the subject first and then connect with lines to fill in the drawing.

Keep moving Your hand should be moving the whole time you're doing a gesture or an action drawing. Once your hand stops moving you lose the connection between your eyes, the subject, and your hand and start overthinking what you're drawing. Move your hand and arm as a unit, allowing loose, fluid marks with your writing tool. This is a great warm-up exercise.

Don't erase Try doing these drawings with a pen instead of a pencil to get over the need to erase mistakes. If you don't like a line you make, just reinforce the ones you do like and let the "off" mark become part of the energy in your drawing.

LESSON 25

Urban street art

| Art Element | Exercise # and Name |
|---|---|
| • • • • | • • • • • |
| My favorite thing about this page is... | |
| My least favorite thing about this page is... | |
| Next time I would do this differently by... | |
| I could apply the technique(s) to my work by... | |

INTENTIONALLY LEFT BLANK

objective

To create your own "tag," or mark, in an urban graffiti style.

Signing our work is usually the last thing we do upon its completion, but graffiti artists incorporate their signature, or "tag," into their artwork. It's also a great place to start when creating your own graffiti-inspired journal page. Creating a tag is a simple process that's fun to do. Once you have it the way you like it, you have a unique way to sign your journal pages—yet another way to leave your mark behind as evidence that you were here and that you created art.

SUPPLIES

Several sheets of scrap drawing paper

Black permanent pens with various nib sizes

Spray inks (you can mix your own in small spray bottles)

Paper towels

White gel pen

Brush

Foam paint stamps or other stamps

Acrylic paint

fig. 1

fig. 2

fig. 3

1 Print your name on the scrap drawing paper using your normal handwriting and a permanent black pen. Begin playing with the letters. Work quickly and keep moving forward, writing your name over and over as you continue to manipulate it. Work until you come up with a tag you like **(Figure 1)**.

2 Write your new tag several times using various pens **(Figure 2)**.

3 Add a frame to your tag, if you like, and continue to practice writing it until it becomes very easy and you can do it without thinking about it **(Figure 3)**.

4 Write your new tag on your journal page with your favorite black pen. Try angling it for added interest **(Figure 4)**.

5 Using a light color of spray ink, spray around the tag. Blot with paper towels if necessary. Let dry **(Figure 5)**.

fig. 4

fig. 5

6 Use a white gel pen to add some designs around your tag and some more writing on the page.

7 Spray additional colored inks around the outside of the white pen doodles. Add spray ink to the inside of the tag as well. Use a brush to move the spray ink inside small areas if needed **(Figure 6)**.

8 Stamp additional word(s) with the foam stamps, using acrylic paint as ink. Let dry and add white highlights to the letters with a gel pen.

9 Continue to add writing, outlines, doodles, and marks to the page until it has the look of a graffiti-covered wall.

fig. 6

LESSON 26

Art on a shoestring

Lesson 26

| Art Element | Exercise # and Name |
|---|---|
| | |
| My favorite thing about this page is... | |
| My least favorite thing about this page is... | |
| Next time I would do this differently by... | |
| I could apply the technique(s) to my work by... | |

1) LOOK FOR MARK MAKING TOOLS IN EVERY DAY HOUSE HOLD OBJECTS

2) MAKE MARKS-USE PAINT, INK + DYE POUNCE, PUSH, PULL-SPLATTER

3) LET YOUR MARKS CREATE THE PAGE WORK WITH THEM LET THEM GUIDE YOU

INTENTIONALLY LEFT BLANK

objective

To use ordinary items from around the house as mark-making tools.

When it comes to "tools" for mark-making, nothing is off the table—not even the eating utensils! Begin to gather supplies for this lesson, looking at everyday objects around your house. I like to keep a basket of such objects by my worktable. I don't even bother to wash these tools because the more paint that builds up on them, the more interesting marks they make. And when they become unusable, there are many more waiting to take their place. So start your search for some interesting new tools to use in your artwork—it's fun and it's free!

SUPPLIES

Mark-making tools found in everyday household items, such as a plastic fork, comb, bubble wrap, toothbrush, suction cup, drywall screw, drinking straw, old credit card, shoestring, etc.

Acrylic paints

Permanent ink pad

Watercolor paints

Brushes

Spray bottle and refill inks, or ready-made spray inks

Stamps (optional)

Assorted journaling pens

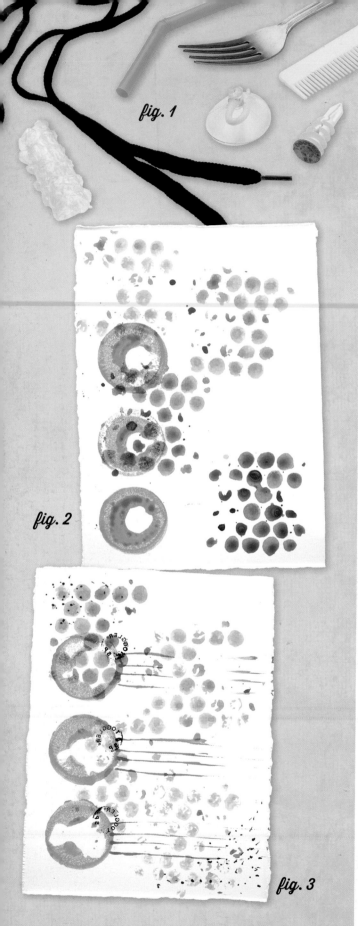

fig. 1

fig. 2

fig. 3

1 Gather together a variety of mark-making tools from around the house (Figure 1).

2 Dip a scrap of bubble wrap into a light color of acrylic paint and randomly stamp onto the page to make bubble marks. Let dry. Use a suction cup dipped into another color of acrylic paint to make circles on the page (Figure 2). Let dry.

3 Make lines by dipping the tines of a plastic fork into acrylic paint and dragging it across the page. Let dry.

4 Use a permanent ink pad to ink a drywall screw or other household object that has text on it and stamp that onto the page.

5 Dip the tines of the plastic fork into another color of acrylic paint and make small dots on the page (Figure 3). Let dry.

6 Paint a very light wash of watercolor paint over the page. Avoid any circles or shapes you wish to leave white. Let dry.

7 Fill a straw partway with watercolor paint by dipping it into the paint and putting your finger over the other opening; about ½" (1.3 cm) of paint will be drawn into the straw. Let the paint drip onto the page in several places and then blow through the straw to "spiderweb" it out. Let dry (Figure 4).

8 Scrape the same paint you used with the bubble wrap onto the page with an old credit card, adding marks by scraping into the paint. Let dry.

9 Load an old toothbrush with an inky consistency of acrylic paint and then run your thumb across it to "fly speck" the page. Run a comb through the inky paint and add marks with it around the edge of the page.

10 Lay a shoestring around the page and mask off the middle by laying a scrap of paper to cover it. Spray watered-down ink from a small spray bottle (or use a ready-made spray ink) over the shoestring. Immediately lift the shoestring straight up. Let dry.

11 Stamp or draw numbers or other text. Use assorted pens to add journaling and details as desired.

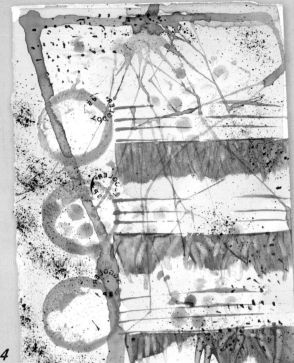

fig. 4

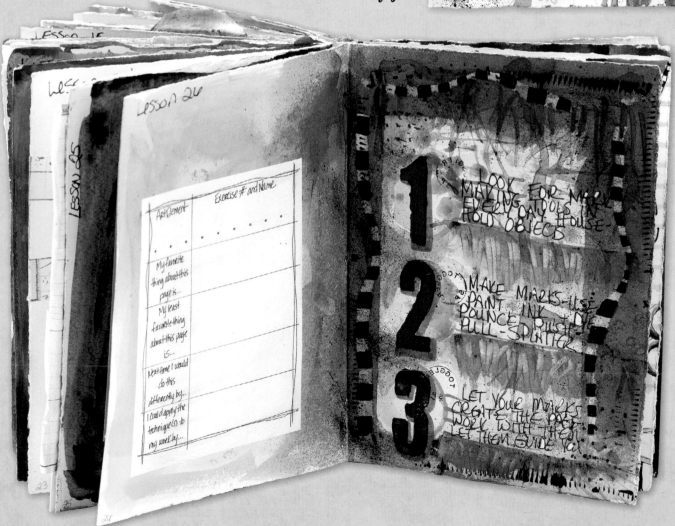

open studio

JOANNE SHARPE

Art Marks →

Watercolors and white gel pen on watercolor paper

"'Art marks' are what I call loose, illustrative elements that add personal expression to my artwork. I like to embellish my paintings and journaling with layers of words, lines, and patterns. In this piece, I used an assortment of pens, markers, brushes, and paint to add decorative art elements. Handwriting, doodling, and repetitive patterns create movement and interest."

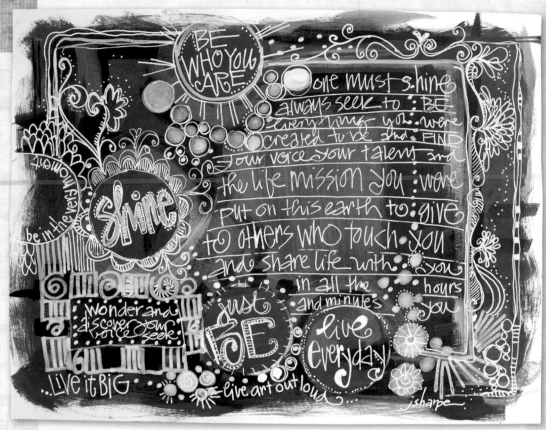

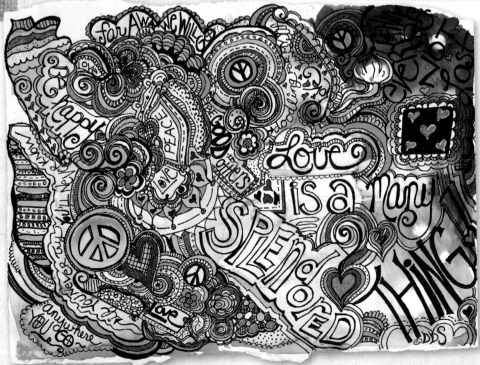

DAWN DEVRIES SOKOL

← **Splendored Love**

Sakura Pigma Micron Pens, Sharpie Oil-Based Paint Pens, Uni-ball Signo Sparkling Glitter Gel Ink Pen, Uni-ball Signo UM-153 Gel Ink Pen in white on watercolor paper

"This piece began as a watercolor background, and I eventually doodled over it. I like to 'weave' my words and doodles together and basically just let my thoughts at the time flow onto the page. I colored in bits and spots with gel and paint pens to boost certain areas."

Artist Q&A

What is your favorite mark-making tool?

SETH APTER It's a toss-up between my sepia, superfine-point Pitt Artist Pen and my white, broad-tip Signo Uni-ball Gel Ink Pen.

LISA BEBI I like a fine-tip Sharpie marker in black for quick drawings and notes. I have them everywhere—in my purse, car, family room, bedroom, garage, and, of course, my art table. I like to have a pen ready to go no matter where I am.

JILL K. BERRY I love No-Blot ink pencils, but they have been discontinued. Now I have to say the Pentel Waterbrush or a Sakura Pigma Micron Pen.

CHRIS COZEN A wooden pointed tool normally used for clay work.

JANE LAFAZIO Pitt Artist Pen from Faber-Castell in black with a superfine point.

JULIE PRICHARD Charcoal pencil.

RENÉE RICHETTS My Crop-A-Dials!!! I use them for way more than their intended purpose, because they are such great metal and paper tools. Besides using them to mark with holes, I use them for making texture patterns.

LESLEY RILEY Red China marker.

MARY BETH SHAW A simple wooden skewer.

DAWN DEVRIES SOKOL I love Sakura Pigma Micron Pens, but I've also been having a love affair lately with chisel-tip Sharpies and a Magnum Sharpie. They work well for scribbling in my urban art journals.

DIANA TROUT Hands down my favorite writing tool is a steel blue Sarasa pen combined with the smooth paper found in composition books. I use wide-rule only, and the lines are merely a suggestion!

SUSAN TUTTLE The pen from my Wacom Intuos Graphics Tablet—my virtual mark-making tool.

alon
et is
pre
cios

face value

Bothing water.
Prof. Damage. 1.17
 2.75

llow Coal Co
velers. Comf. 41.82

C, Gelineau M.D.
velers.-Studebaker. 3650 5.
Prof. Damage. 12.10 2/
Ford.- 13.50
Prof. Damage 4.95
Cr 6.65 1/
cancellation on 33.74
 3

J. Y. J. Zolie

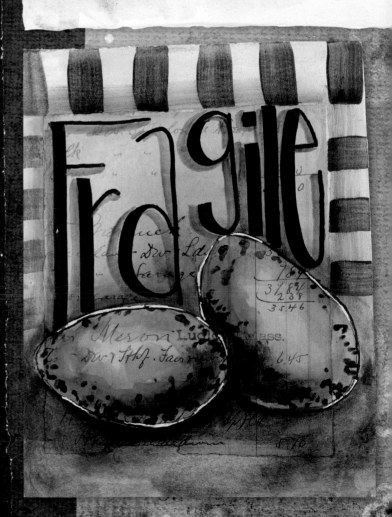

Fragile

 189
 31.8 3/4
 2 3/8
 35.46

Meson Luck
Dw V Shf. Fair 6.45

 6.70

the value of shading

EXPLORING THE ELEMENTS OF LIGHT AND DARK

In Chapter 5, we explored ways to create actual and implied three-dimensional forms in our work. In this chapter, we'll go into more depth (pun intended) to create the illusion of form through the use of shading. By shading, or changing values, we can turn squares into cubes, circles into spheres, and triangles into cones. **Value** simply means the degree of light and dark in a design, from black to white and all the mid-tones in between. Value can also be achieved with **tones** (adding black) and **tints** (adding white) to colors. Shading is often overlooked in collage work and journal pages, leaving them looking a little flat. In this chapter we will practice creating depth with just a touch of charcoal, a swipe of conté crayon, or the stroke of a pencil.

QUICK LOOK

| lesson | objective |
|---|---|
| **27 SHADES OF GRAY** | To achieve depth and dimension using gray and black brush pens. |
| **28 TROMPE L'OEIL—FOOL THE EYE** | To take a photo and change its setting to "fool the eye" through the use of shading. |
| **29 SKETCHING WITHOUT PENCILS** | To use graphite in an alternative form to create sketches without using a pencil. |
| **30 AT FACE VALUE** | To create a self-portrait using a subtractive method. |

LESSON 27 *Shades of gray*

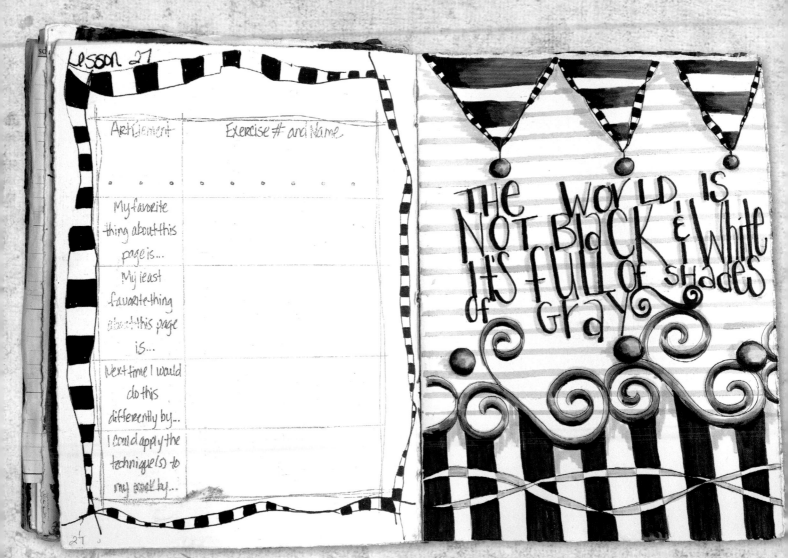

Lesson 27

| ArtElement | Exercise # and Name |
|---|---|
| | |
| My favorite thing about this page is... | |
| My least favorite thing about this page is... | |
| Next time I would do this differently by... | |
| I could apply the technique(s) to my work by... | |

THE WORLD IS NOT BLACK & WHITE IT'S FULL OF SHADES OF GRAY

INTENTIONALLY LEFT BLANK

objective

To achieve depth and dimension using gray and black brush pens.

SUPPLIES

Graphite pencil

Faber-Castell Pitt Artist Brush Pens in Shades of Grey

Faber-Castell Pitt Artist Brush Pens in Black

In life we see everything because a light source reflects off a surface. These reflections are never pure, solid colors, but rather varying degrees of light or dark. In this lesson we will explore value by using brush-tipped pens to create simple gray tones.

A BRUSH WITH VALUE

Brush pens have ink built right into them, allowing you to apply the ink without having to dip a brush into a separate container. There are several types available. I'm partial to Pitt Artist Brush Pens from Faber-Castell. The ink is extremely lightfast and waterproof as well as pH neutral and acid free. The unique brush point ensures an even flow of ink, gliding gently and smoothly over the paper. By varying the angle to create fine, medium, and broad strokes, as well as shading of various kinds, you can achieve a personal touch to your script or lines.

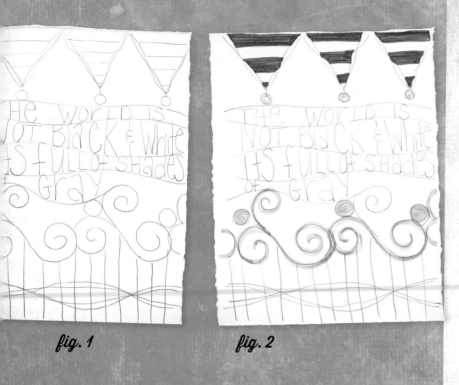

fig. 1

fig. 2

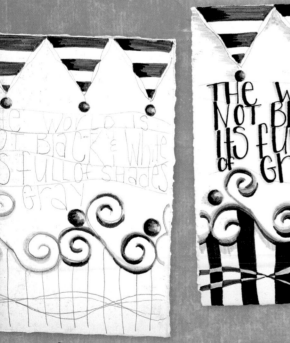

fig. 3

fig. 4

1 Draw some scrolls and other simple design elements with a pencil. Think about basic shapes more than complex images. Some elements you can include on your pages are stripes, triangles, and circles. Work around the outside edges of the page. Add wavy lines to the middle of the page and add journaling **(Figure 1)**.

2 There are three warm grays and three cool grays in the Shades of Grey set; choose whether you want to work in warm or cool grays. Begin with the lightest color of gray brush pen and follow the scrolling lines, varying the thickness by changing the pressure put on the tip of the pen. Color in circles and use a medium-gray pen to color in some of the areas as well **(Figure 2)**.

3 Use a medium-gray brush pen to begin shading the undersides of the scrollwork. Continue shading by adding the darkest shade of gray brush pen to the underside, using less of this color than you did with the others. To help blend the colors, use the lightest shade of gray pen as a blending tool, working the darker shades into each other. This can only be done while the ink is still wet, because once it dries it's permanent **(Figure 3)**.

4 Continue coloring in all of the designs in the same fashion. Shade around them with the lightest shade of gray brush pen. Use black pen over the lettering and the lightest shade of gray brush pen to add shading to one side of the letters **(Figure 4)**.

5 Outline the shapes with the black Pitt pens. Vary the nib size for added interest. Add cross-hatching to some areas for added interest.

SHADING STYLES

There are a number of ways to incorporate shading into your artwork. Experiment to see which method works best for you.

Cross-hatching Cross-hatching is the use of intersecting parallel lines to create shading. The closer together the lines are, the darker the shading will be. Using a fine-tipped drawing **tool**, quickly draw lines in a diagonal direction and then cross them going in the other direction. You can use cross-hatching in combination with blending to emphasize dark areas and add texture.

Blending Blending creates a smooth transition between light and dark tones. If you're working with charcoal or pencil, you can use a blending stump. To blend with brush pens or other forms of ink, apply the ink on a slightly damp page, starting with the lightest shade, and blend in progressively darker shades. Remember to use less and less color as the shades get darker.

Stippling Also called **pointillism**, stippling means to create texture and shading with dot marks. The closer together the dots are, the darker the shading will be. You can also use different shades of ink and experiment with different nib sizes.

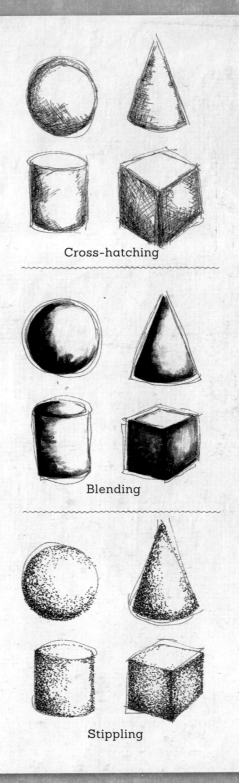

Cross-hatching

Blending

Stippling

Trompe l'oeil—fool the eye

objective

To take a photo and change its setting to "fool the eye" through the use of shading.

Through the clever use of shading techniques, mural artists often fool the eye by creating scenes that make you feel like you're peering through a window or looking at a three-dimensional object, like a vase sitting on a table. In this lesson we'll create our own *trompe l'oeil* effect by taking a photo and placing it into a whole new scene.

SUPPLIES

Black-and-white photo with a strong central image (vacation photos work well)

Mixed Media Adhesive or other collage glue

Graphite pencil

Brushes

Acrylic paints in assorted colors, including Payne's grey, white, and transparent yellow iron oxide

Color photo of an object

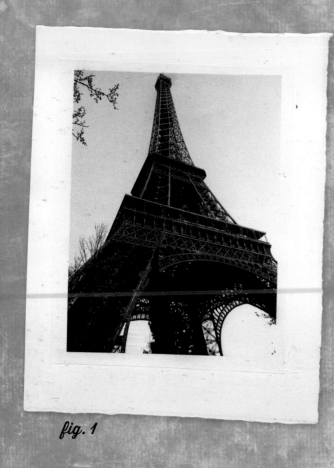

fig. 1

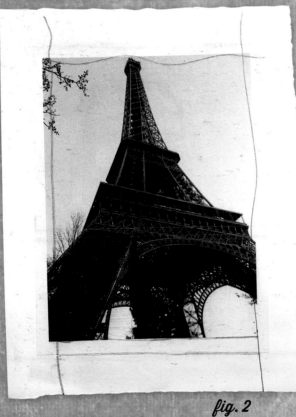

fig. 2

1 Photocopy or print out a black-and-white copy of a photo. I like to use vacation photos for this exercise. You may want to crop the photo to focus on one strong focal point, such as I did with the Eiffel Tower.

2 Adhere the photo to your page with Mixed Media Adhesive or other collage glue and let dry **(Figure 1)**.

3 Create a "faux" setting like a window or door around the image, using a pencil to sketch the details **(Figure 2)**.

4 Use acrylic paints to block in color areas of both the sketch and the photo **(Figure 3)**.

5 With acrylic paint, block out any unnecessary details in the photo and make any desired changes. Remember, you can change the color of the sky from day to night, sunny to rainy, or whatever you like **(Figure 4)**.

6 Print or photocopy a color photo of an object, sizing it large enough that it appears to be closer to the viewer than the main image. Cut it out and adhere it to the page with Mixed Media Adhesive or other collage glue.

7 Use Payne's grey acrylic paint to shade around the object, making it appear to sit in front of the main/background image.

8 Shade the frame around the photo. Create shadows by mixing the main paint color with a bit of Payne's grey, and create highlights by adding warm paint tones such as transparent yellow iron oxide. Make the highlights "pop" with small touches of white paint.

9 Add extra details, such as tree branches, to further enhance the new setting for your main image.

fig. 3

fig. 4

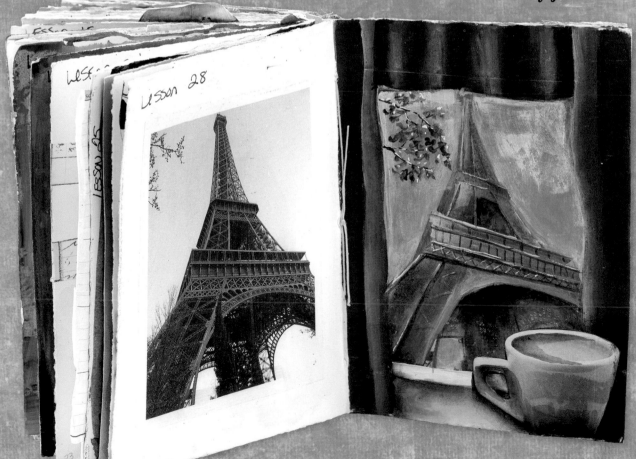

LESSON 28

Sketching without pencils

Lesson 29

| Art Element | Exercise # and Name |
|---|---|
| • • • • | • • • • |
| My favorite thing about this page is... | |
| My least favorite thing about this page is... | |
| Next time I would do this differently by... | |
| I could apply the technique(s) to my work by... | |

INTENTIONALLY LEFT BLANK

objective

To use graphite in an alternative form to create sketches without using a pencil.

Adding a new medium to your mixed-media stash is a great way to breathe new life into your work. My signature Derivan Liquid Pencil Sketching Inks are actual graphite in a liquid form. They come in both permanent and rewettable forms that can be applied with anything from a paintbrush to a dip pen to a rubber stamp, and more. So let's "get the lead out" and add some graphite value to the page.

SUPPLIES

Old book or ledger page

Mixed Media Adhesive or other collage glue plus transparent gesso

Brushes

Pencil

Derivan Liquid Pencil Sketching Ink (permanent and rewettable forms)

Blending stump

White gesso

Watercolor paints

Bone folder

Watercolor palette with wells

Dip pen

Faber-Castell Pitt Artist Brush Pens in Shades of Grey

fig. 1

fig. 2

1 Adhere part of a book or ledger page to your journal page using Mixed Media Adhesive, and let dry **(Figure 1)**.

2 Sketch a simple object(s) such as eggs onto the page and add a horizon line using a pencil **(Figure 2)**.

3 Apply Permanent Liquid Pencil Sketching Ink directly to the page with the applicator tip. Use it to create organic speckles on the eggs or other marks to enhance your design.

4 Apply Rewettable Liquid Pencil Sketching Ink with a wet brush to shade the area below the horizon line under the eggs. Let dry **(Figure 3)**.

5 Use a blending stump to blend the dry Rewettable Liquid Pencil to shade above the horizon line and around the eggs **(Figure 4)**.

note Once you have some of the dry Rewettable Liquid Pencil on the blending stump you can continue to smudge it around to areas where no Liquid Pencil was applied.

6 Add a bit of white gesso to the ledger/book page to help tie it into the background. Let dry.

7 Use watercolor paints to paint the eggs and add color to the background. Keep things transparent so the text shows through.

8 Use a bone folder to burnish the Permanent Liquid Pencil Sketching Ink until it has a sheen to it.

9 Place a small amount of Permanent Liquid Pencil Sketching Ink in a well of the watercolor palette. Dip a pen into the ink to add details and journaling. Add more journaling and shade letters using Pitt Brush Pens in Shades of Grey.

fig. 3

fig. 4

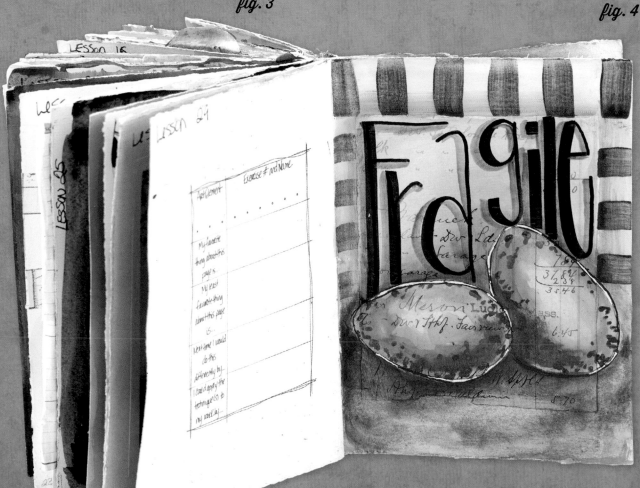

At face value

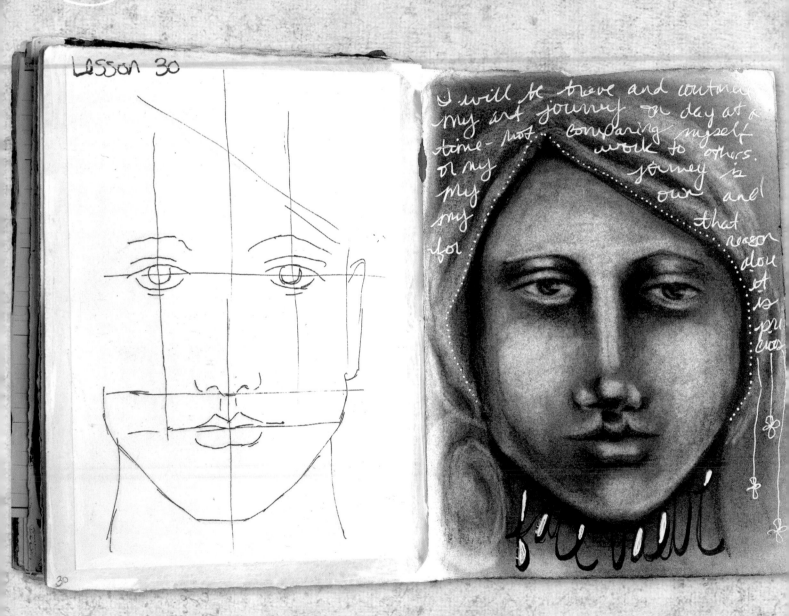

I will be brave and continue my art journey one day at a time – not comparing myself or my work to others. My journey is my own and for that reason alone it is precious

face value

objective

To create a self-portrait using a subtractive method.

Creating a self-portrait can be intimidating if you're not accustomed to drawing faces. The key is to remember that it doesn't have to be an exact replica of your face. You are creating the "essence" of you, not a mirror image, and this journal exercise is intended to help you do just that. You will learn some simple techniques that teach the tonal values of shading and be able to create a self-portrait that reflects the inner you.

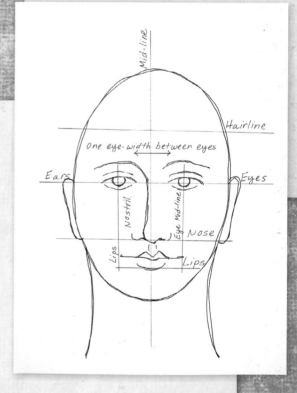

FACE MAPPING

You can use this "face map" to give you some guidelines for drawing a face. Remember that these are just hints to get you started. You can make adjustments as you go and create a face that is uniquely you.

Some "rules" for drawing faces:

★ **The eyes are at about the vertical halfway point of the face.**

★ **There should be one eye width between the eyes.**

★ **The face is about five eyes wide.**

★ **The bottom of the nose is halfway between the eye line and the chin.**

★ **The nostrils align with the inside corners of the eyes.**

★ **The ears are about the same height as the distance from the midpoint of the eyes to the bottom of the nose.**

★ **The corners of the mouth extend to the middle of the eyes.**

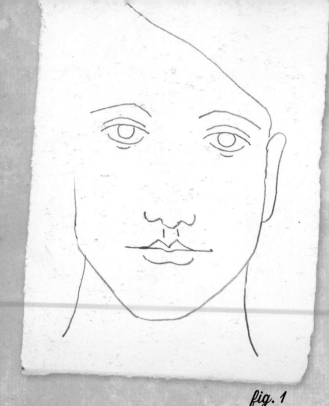

fig. 1

1 Draw a simple sketch of a face onto your jour-
 nal page using pencil. Don't use any shading,
 just simple outlines of the details **(Figure 1)**.

tip

★ If you don't want to draw your own face, you can
 also make a copy of a photo and outline the basic
 details with a black permanent pen. To transfer
 the details, turn the copy over and hold it against
 a window with the light shining through. Use the
 conté crayon to draw the details on the back of
 the paper and place it on your journal page conté
 crayon side down. Trace over the design with a
 stylus or a ballpoint pen to transfer the design
 quickly and easily.

2 Use a black conté crayon to shade the shad-
 owed areas of the face. Make quick strokes us-
 ing the flat edge of the crayon; don't overwork it
 at this point **(Figure 2)**.

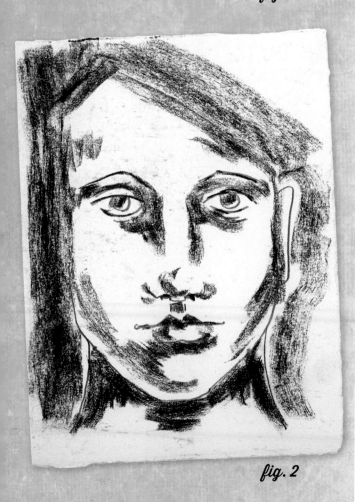

fig. 2

3 Take a facial tissue and wipe over the entire surface of the conté sketch. Use a circular motion and smudge the crayon. (This might take a little bit of guts, but you can do it!) Don't worry about what it looks like at this stage. You're building a sketch layer by layer **(Figure 3)**.

4 Add the highlights back in using your kneaded eraser to lift off the crayon in the areas you want to highlight. Remember to establish your light source and stay consistent. It takes very little pressure to remove the crayon, so use a light hand **(Figure 4)**.

5 Repeat steps 2 through 4 two or three times to build tonal values. Apply less crayon each time, focusing on the deepest shadow areas.

6 Sharpen the pencil eraser to a point to get into tiny areas, such as the eyes, to add fine highlight details. Erase highlights around the face to create hair. Use the chisel edge of the conté crayon to add finishing details to the eyes and mouth. Spray with a fixative to keep it from smudging.

7 Add journaling to the page as desired with assorted pens.

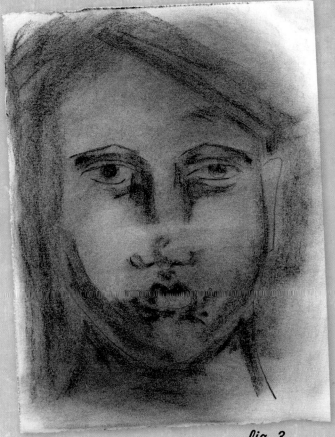

fig. 3

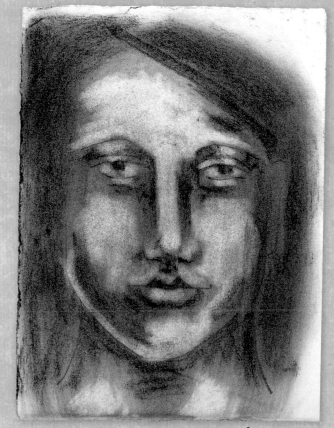

fig. 4

open studio

JANE LAFAZIO

Buon Giorno! →
*Water-soluble pen, watercolor, and vintage
book page on sketchbook page*

"Working with just one color of water-
soluble pen helps me focus on just the
darks and lights of an object. By look-
ing carefully at the shading of an object
and where the light falls, I can paint the
illusion of volume and shape with just
variation in value. A successful artwork
usually has a full range of values, from
darkest dark to white. In watercolor,
there's no white, so the white of the
paper must be left unpainted to achieve
the lightest values."

LISA BEBI

← Toy Boat Boy
Acrylics, collage, and pen on Bristol board

"In my work, I often like to minimize depth
of field to create a mood or unique environ-
ment for my subject. I do this by limiting my
palette and using large paintbrush strokes on
the background, leaving only hints of depth
for a bit of intrigue. Some background areas
are darker than others. To me, limiting values
brings my subjects into clearer focus, and,
hopefully, portrays a dreamy feel or mood."

Artist Q&A

What is your favorite shading medium and method?

LISA BEBI I am mostly a painter; I don't use pencil. So to shade with paint, I usually paint in mid-tones first, and then add the darker, shadowy colors. I add the highlights last.

JILL K. BERRY I use graphite pencils, from HB to 6B, to get the shades I need for drawing in my journal.

CHRIS COZEN This is definitely a job for acrylic glazes! Being able to quickly add a shadow or dimension with a glaze and see the difference immediately is so exciting. It's those subtle touches that make a work complete. I am not averse to throwing in a bit of oil pastels occasionally if I'm looking for a good smudge, though!

JANE LAFAZIO Lately, I've been enamored with water-soluble pens and pencils. I use just gray or black and then add water to blend.

JULIE PRICHARD Acrylic paint and Acrylic Glazing Liquid.

LESLEY RILEY I mostly work with fabric, but when I do draw, I like to blend with my finger or a stump, and with watercolor, I love to let colors bleed.

MARY BETH SHAW I love using a Derwent Inktense pencil to shade. I dip it into water and allow the color to bleed out.

DAWN DEVRIES SOKOL Stabilo pencil and my finger.

DIANA TROUT I love to use transparent layers of color when I'm painting to add depth. With watercolor, I wet the area first and then float the color into it. Watching the color spread out into the water is both satisfying and entertaining. With acrylics, I use glazing mediums so that transparent layers can be built up. The best part of a portrait for me is that little shadow cast onto the upper eye by the eyelid. One perfect stroke in exactly the right tone just gives me a thrill.

the End of the ROAD?

As you finish the last lesson in this book and close your now-full journal, you will likely feel a sense of satisfaction, and rightly so. You did it! You completed the course! What a great feeling to have set out to do something and then followed through with it. And you have the evidence of your journey right before you in your completed journal. This great feeling may last a few hours or even a few days, but it will likely be followed by the question, "What's next?" You've been working so hard and with such purpose that you are left feeling a little empty now that you've finished.

What's next? Where do you go from here? I'm hoping that you are now so hooked on the journaling habit that you'll go right into your next journal without missing a beat. Mix up these techniques, revisit a favorite, or even retry one that gave you a little trouble. Look at the notes you took beside each lesson as a map of where you want to take that technique next. Incorporate one or two of the techniques into work you already do. Create a whole journal using just one of the lessons for an in-depth study of a particular technique. Do whatever you want, as long as you keep moving.

The amazing thing about creativity is that the more you create, the more creativity builds up inside you. You've begun a trip that can last you a lifetime if you keep going forward with excitement for what may be around the next bend in the road. The most wonderful and amazing thing about creating art is being on the journey. It's the journey, not the destination, that we should focus on, enjoying every twist and turn as we cruise along life's highway.

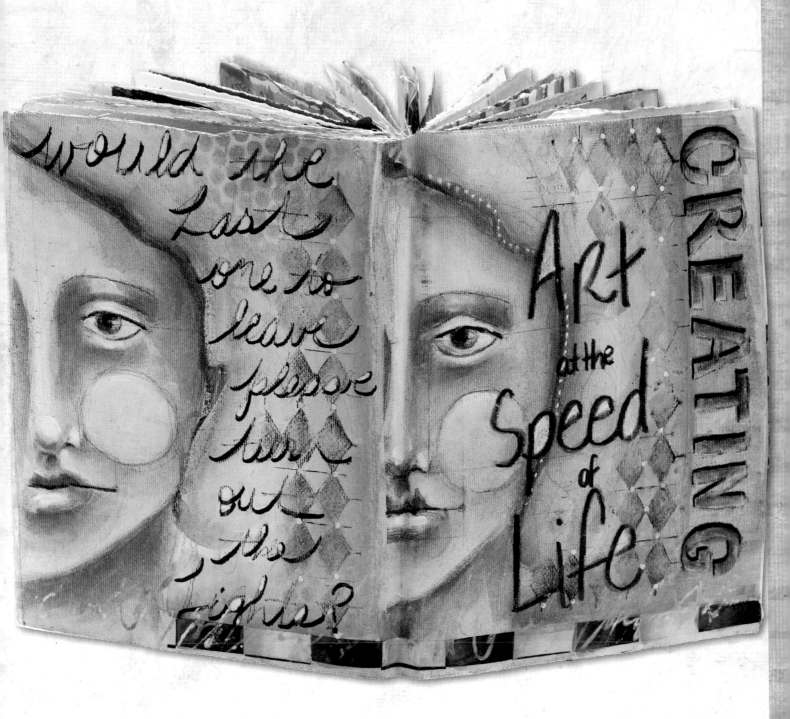

mixed-media Glossary

Vocabulary

Throughout the lessons, I use a number of mixed-media art terms you might not be familiar with. Here are some basic definitions.

Burnish To rub a surface in order to transfer an image or buff a medium such as graphite to a sheen; usually done with a tool such as a bone folder or the back of a spoon.

Collage To adhere images and scraps of papers in an overlapping manner.

Color wash A thinned-down water-based paint.

Cross-hatch To create lines in one direction and then lay lines on top in the opposite direction to create shading.

Dry-brush To create a scratchy effect by applying a small amount of paint with a dry brush.

Flyspecking Running the thumb across the bristles of a small brush, like a toothbrush, loaded with thinned-down acrylic paint to simulate fly specks on old papers.

Folio One piece of paper folded in half to form four book pages.

Glaze Acrylic medium and paint mixed to form a transparent wash that doesn't obscure the details underneath; it has a longer working time than acrylic paint alone, and different colors can be achieved by layering glazes.

Image transfer Technique in which you move just the ink of an image to your artwork.

Linocut Linoleum block carving.

Masking Covering an area of your artwork before painting over the rest to preserve a shape.

Pounce To create short up-and-down strokes with a flat-head stencil brush.

Resist Medium(s) that won't accept paint.

Signature Several (usually three to five) folios nested within each other; multiple signatures bound together form a book.

Stippling Small dots made with pencil or pen to create varying degrees of shading; also called pointillism.

Tooth Roughness (as in paper) necessary to accept and absorb paint and other wet media; also helpful in making dry media, such as pastels, stick.

Trails Ridges or marks left by carving.

Undercut Carving term in which you cut under the edge of the design, making it less stable.

Under-journaling A layer of writing over which paint and other media are applied.

Wet-on-wet Describes a technique in which you wet a substrate with water before painting on it; allows colors to bleed into each other.

Basic Supplies

By playing with basic supplies in new ways and experimenting with new materials, you can add to your arsenal of mixed-media techniques. If you don't have a tool or material used in a lesson, check out the definitions below for possible substitutions. If you do substitute, make notes on the page so later you can remember what you did and whether or not it worked for you.

Acrylic paints Acrylic paints come in both **fluid** and **heavy-bodied forms**; heavy-bodied paint can be thinned with water and acrylic paint medium to a fluid consistency.

Awl Metal tool with a sharp point used for making marks, scratching through layers of paint, and creating holes in paper for bookmaking. **Substitute**: Upholstery needle.

Bingo dauber bottle Sponge-tipped bottle that can be filled with paint glazes and washes and capped, allowing you to save and reuse paint mixtures. **Substitute**: Mix paint glazes and washes directly on palette.

Blending stump Double-ended, pointed stick made of soft gray paper, used for blending charcoal, soft pastels, and even graphite; can be sharpened or sanded. **Substitute**: Cotton swab, finger.

Blending stump

Bone folder Flat tool with both a pointed and a rounded end used for making crisp creases when folding paper and for burnishing; usually made of bone. **Substitute**: Back of spoon.

Bookbinding needle Blunt-tipped, 2" to 4" (5 to 10 cm) needle used for poking holes in paper. **Substitute**: Any large-eyed sewing needle.

A few of my favorite supplies (from left to right): Mixed Media Adhesive, bingo dauber bottle, Liquid Pencil Sketching Ink, and sequin waste (front).

BINGO DAUBER BOTTLE ACRYLIC PAINT RECIPE

In the bottle, mix together:

One part acrylic paint

Two parts water

One part acrylic painting medium (paint extender/drying retarder)

This will give you a watercolor-consistency glaze, great for adding layers of transparent color to journal pages quickly and easily. Keep the bottle capped so the glaze doesn't dry out, and shake before using.

Bookbinding tape Cloth tape used for assembling books.

Brayer Rubber roller used to apply paint or ink to a stamp and for printing; comes in both hard (for inking) and soft (for printing) rubber; also handy for gluing collage material to a substrate.

BRUSH SENSE

There are so many different types and price points of brushes that it's really a personal decision based on what works for you. I usually use Loew-Cornell angled flats. If you're a messy worker, buy cheap brushes you can throw away without guilt. If your work is very detailed, high-quality, fine-tipped brushes might be worth the expense. Here are a few specialty brushes you might want to try.

Aqua brush A watercolor brush with a water-filled handle used to dilute watercolor as you paint. *Substitute*: Watercolor brush

Chip brush An inexpensive brush used for applying wax or encaustic medium, gesso, mediums such as matte gel, and other materials that don't require a good brush.

Sponge brush Cheap, disposable brushes made of foam that leave no brushmarks on your work. *Substitute*: Sponge applicators used for makeup

Stencil brush A stiff, flat-headed brush used for "pouncing" paint onto stencils.

Conté crayons

Conté crayon Conté crayons are sticks of compressed charcoal or grphite mixed with clay or wax.

Cutting tools A variety of cutting tools makes any job easy; I use micro-tipped **scissors** with soft handles (Fiskar), a **craft knife**, and **precision cutters**, like Scotch Brand Cutters.

Ephemera Old written or printed papers that weren't meant to be kept, such as ledger pages, ticket stubs, receipts, labels, etc.

Gelato Water-soluble pigment sticks from Faber-Castell that have a creamy texture and come in a variety of colors.

Gesso Used to prep a substrate and create tooth for paint or other mediums to grab on to. **Clear gesso** can be mixed with paint to create a colored background, or used on top of a painted background to prep it for use with pastels. **White gesso** is commonly used to prep canvases or watercolor paper for painting; it can also be mixed with paint or used to create a resist effect. **Black gesso** is great for prepping substrates where a darker color palette will be used.

Graphite pencils While any pencil will work for most of the lessons in this book, Woodless graphite pencil I prefer woodless graphite pencils; they provide more working surface and are great for shading techniques.

Heat tool Used to help speed the drying process, providing more heat than a blow dryer with less wind force. *Substitute*: Blow dryer on low setting or with a diffuser attachment.

Inks Permanent inks, such as Tsukineko, StazOn, or India inks, can be used under wet media without worry. ColorBox Chalk Ink is a unique kind of dye ink with a chalky look that is permanent when heat set.

Kneaded erasers Pliable erasers that can be formed into any shape and erase cleanly, leaving no eraser crumbs behind; great for removing pencil, chalk, charcoal, and soft pastel, and for creating highlights.

Kneaded eraser

Liquid Pencil Sketching Ink My signature ink from Derivan that allows you to create graphite pencil effects and pencil sketches with a brush, pen nib, or other art tool; it can be painted, erased, burnished, stamped, and troweled, offering a wide variety of applications. **Substitute**: Water-soluble graphite pencils.

Loew-Cornell Berry Maker Sponge-tipped tool for making dots with paint.

Loew-Cornell Fine Line Painting Pen Brass writing tool that holds thinned paints and inks in a well.

Loew-Cornell Fine Line Painting Pen (top) and Berry Maker (bottom)

Masks Materials used to cover a portion of artwork, protecting it as additional layers of color are applied; when removed, the original color where the mask was remains intact. Clear contact paper, masking fluid, and painter's tape can be used as masks.

Mixed Media Adhesive My signature product line of ultra-matte medium from Derivan that can be used as a collage glue. **Substitute**: Gel medium or collage glue with a layer of clear gesso over it.

Palette Surface used for mixing paint. The most common types are plastic or disposable waxed paper tablets. For watercolor, use a palette with wells to hold the paint.

HAPPY MEDIUMS

A medium is a material added to acrylic paint to change the consistency or provide other effects; I use Derivan Matisse mediums, but most companies that produce acrylic paints also have mediums. Here are the ones I use most often.

Acrylic paint medium Specially formulated liquid medium designed to increase working time. Very useful for fine-art applications in which subtle blending, subtractive techniques, and similar methods are desired. Available in gloss and satin finishes. **Substitute**: Acrylic glazing medium.

Block printing medium A water-based medium that when mixed with heavy-body acrylics creates a blend ideal for making block prints on paper, canvas, and more.

Drying retarder Medium used to extend the drying time/workability of acrylic paint. I add it to my custom bingo dauber bottles to keep the paint from drying and clogging. **Substitute**: Open medium.

Impasto medium Thickening agent used to make acrylic paint spreadable; can be used to create textured or smooth surfaces. **Substitute**: Molding paste.

Surface tension breaker Medium designed for modifying acrylics for airbrush/spray application; can also be used to thin down acrylic paint and extend its working time. **Substitute**: Airbrush medium.

Palette knife A long plastic or metal spatula used for mixing and applying paints. *Substitute:* Old credit card, hotel key, or other plastic scraping tool

PanPastels Professional-quality pastels in pans; they are highly pigmented, have excellent lightfastness, are erasable, and are fully compatible with traditional soft pastel sticks, pastel surfaces, and conventional fixatives. *Substitute:* Pastel pencils or soft pastel sticks

Sealants Material that protects the surface of artwork from dust, stains, light, and moisture, and prevents smudging. Spray sealant should be applied in a well-ventilated area; apply several light coats. *Substitute:* Apply a coat of Mixed Media Adhesive or other collage glue as a final coat

Sequin waste Sometimes called **punchanella**, it really is the "waste" that's left over when sequins are made! Used like a stencil to create texture in layered backgrounds. *Substitute:* Punch holes into cardstock or an old file folder with a hole punch

Sofft tools Sponge-tipped tools specifically developed for use with PanPastels; can also be used with most water-based art and craft materials to create a variety of marks and effects, with no visible brushstrokes. *Substitute:* Sponge applicators used for makeup, sponge brushes, cotton swabs, and soft paintbrushes

Sofft tool

Stencil Template created to reproduce the same pattern or design with paint or ink.

Washi A type of Japanese paper tape.

MIGHTY PENS

Brush pens Pens with a brush tip; can be used to mimic brushstrokes in decorative writing and coloring, and are great for inking up stamps.

Dip pens Also called nib pens, these writing tools have a metal nib like a fountain pen that you dip into ink.

Gel pens A writing pen that contains a pigmented, gel-based ink; white gel pens are perfect for adding details and writing that "pop" off of journal pages.

Permanent pens I use Faber Castell Artist Pens; they come in a variety of nib sizes and contain India ink, which is permanent when dry and does not bleed through paper.

Watercolor paper **Hot press** has a smooth surface, while **cold press** is rougher; comes in different weights—the higher the weight, the thicker the paper.

Water-soluble media Graphite pencils, colored pencils, and crayons all come in forms that are applied dry but become paintlike when activated with water or liquid medium.

Waxed linen thread Thread used for bookbinding that has a wax coating on it to make it easy to pull through paper.

STAMP IT

There are several types of stamps available. Here are a few I like to use for journaling and mixed-media applications.

Clear stamps See-through polymer stamps that cling to acrylic blocks for traditional stamping, but can be used alone for mixed-media applications.

Foam stamps Inexpensive stamps made from foam rubber for use with paints.

Objects Many things can be used to stamp an image, including food! Look around to see what might make a unique pattern and try it out.

Unmounted rubber stamps These generally come in sheets with several designs that you cut apart; you can use them as is in mixed-media applications or mount them on a stamping block for more traditional stamping techniques.

Wood-mounted rubber stamps These come ready to use and work well for traditional stamping techniques.

clip art

A number of lessons in the book incorporate portraits and other sketches. You can draw your own or feel free to copy and transfer the images shown here. You may want to enlarge or reduce them on a photocopier to fit your journal page.

contributing *artists*

SETH APTER
Seth Apter is an artist, author, and instructor from New York City. His work has been exhibited throughout the United States and Canada. He is the voice behind The Pulse, a series of international, collaborative projects that are the basis of his book *The Pulse of Mixed Media* (North Light Books, 2012). He is also the artist behind two DVDs: *Easy Mixed Media Surface Techniques* and *Easy Mixed Media Techniques for the Art Journal* (both North Light Media, 2012).
thealteredpage.blogspot.com

LISA BEBI
Lisa Bebi received a fine arts degree from San Diego State University. She has won many awards and commissions for her work. While her primary medium is acrylics, she also works in mixed media and collage.
lisabebi.blogspot.com

JILL K. BERRY
Jill is a mixed-media artist and teacher. She focuses her work on text, color, and social issues. You can see examples of her art in *Somerset Studio*, *Letter Arts Review*, *Cloth Paper Scissors*, and *Art Journaling* magazines, and her book, *Personal Geographies* (North Light Books, 2011). Jill has taught at three universities in Colorado and various other institutions nationally.
jillberrydesign.com
jillberrydesign.com/blog
personal-geographies.com

CHRIS COZEN
Chris Cozen is a primarily self-taught artist who enjoys exploring color, texture, and pattern in her art. She is a Working Artist for Golden Artist Colors, Inc. and presents lectures and workshops throughout the United States. Chris has published three books: *Altered Surfaces* (2008), *Transfers and Altered Images* (2009), and *Mixed Media and Color* (2010) with Design Originals. Her online classes with Julie Prichard can be found at thelandoflostluggage.com. Chris's latest book (with Julie Prichard) is *Acrylic Solutions* (North Light Books, 2013).

CHRISTY HYDECK
Never leaving home without a camera by her side, artist, photographer, and author Christy Hydeck takes delight in life's simple pleasures and immerses herself in all things artistic. Christy lives with bipolar disorder and Tourette's syndrome and credits her sense of stability to the huge role that creativity plays in her life. She is the coauthor (with Susan Tuttle) of *Photo Craft* (North Light Books, 2011).
alwayschrysti.com

JANE LAFAZIO
Jane LaFazio, a full-time artist since 1998, truly believes she is living the life she was meant to live! In that time, she has cultivated a wide range of skills as a painter, mixed-media artist, quilt artist, and art teacher. Jane's artwork has been featured in *Cloth Paper Scissors* and *Quilting Arts* magazines many times, and in Danny Gregory's *An Illustrated Life* (HOW Books, 2008).
janelafazio.com

JULIE PRICHARD
Multimedia artist Julie Prichard lives in San Diego, California, where she hosts thelandoflostluggage.com, a website that offers a wide array of convenient, supportive, and enjoyable workshops for all levels in many art forms.
thelandoflostluggage.com

RENÉE RICHETTS
Renée Richetts has successfully maintained dual careers as an artist and R.N. for more than a quarter century. Renée splits her time between her art studios in Escondido, California, and Chicago. Her work can be seen at the Escondido Municipal Gallery, at the Girl Scout Museum in New York City, and in UC San Diego's Special Collection at Geisel Library. She can be contacted via Facebook or at rrichetts@cox.net.

LESLEY RILEY
Lesley Riley is an internationally known artist and author of four craft books whose art and writing has appeared in numerous publications and online sites. She has taught workshops all over the world and developed the highly popular TAP® Transfer Artist Paper.
lesleyriley.com

JOANNE SHARPE
Joanne Sharpe is a mixed-media artist and teacher with a passion for art journaling, doodling, and illustration. She is known for her signature style of hand lettering. Joanne recently launched a workshop DVD called *Artful Lettering* (Interweave) and is work-

ing on a book to be published by Interweave in 2014. Joanne's art has been featured in *Cloth Paper Scissors*, *Studios*, *Somerset Studio*, *Somerset Art Journaling*, and *Somerset Apprentice* magazines. She has been licensing artwork to the craft, fabric, and giftware markets for two decades. Joanne resides in Rochester, New York.

joannezsharpe.blogspot.com

joannesharpe.etsy.com

MARY BETH SHAW

Mary Beth Shaw works in mixed media because she loves to play with art supplies. Her process utilizes pastel, ink, marker, and acrylics layered with various collage, texture, and three-dimensional materials. She is author of *Flavor for Mixed Media* (North Light Books, 2011), writes a column for *Somerset Studio*, and is the owner of StencilGirl Products. Mary Beth lives in Missouri with her husband and three cats.

mbshaw.blogspot.com

stencilgirlproducts.com

mbshaw.com

DAWN DEVRIES SOKOL

Dawn DeVries Sokol is the author of *Doodle Diary: Art Journaling for Girls* (Gibbs Smith, 2010), *Doodle Sketchbook: Art Journaling for Boys* (Gibbs Smith, 2011), and **1**,000 *Artist Journal Pages* (Quarry, 2008). She teaches online retreats through her blog, has a DVD with Interweave called *Art Journaling: Pages in Stages*, and has written for *Cloth Paper Scissors*, *Pages*, *Art Journaling*, and *Art Journaling Exposed* e-mag. Her latest book, *Art Doodle Love* (2013), is published by Abrams/STC Craft.

dawnsokol.com

DIANA TROUT

Diana Trout trained as a painter at Pennsylvania Academy of the Fine Arts. She exhibits her mixed-media artwork at galleries and shows. She has been teaching journaling, book arts, and mixed-media art since 1993, and her artwork and articles have appeared in national magazines and art zines. She is the author of *Journal Spilling: Mixed Media Techniques for Free Expression* (North Light Books, 2009).

dianatrout.typepad.com

SUSAN TUTTLE

Susan Tuttle is a photographer, a digital artist, an author of three books published by North Light Books, and an online Photoshop instructor. She lives in rural Maine.

susantuttlephotography.com

Acknowledgments

With "Book Two" comes a whole new realization that there is always more to learn! If we stop learning, we stop growing, but thankfully each new challenge is an opportunity for personal growth. The key is to keep challenging yourself.

I'm very thankful for the many talented artists who have contributed their inspirational artwork to this book. Not only are they wonderful people and amazing artists, but they also exemplify professionalism in the art world, and I'm honored to call them friends.

To my dearest husband, I owe you a heartfelt thank-you. You are always there in good times and bad, and without your support, none of this would have ever been possible. To my sons and grandsons, may you always go after your dreams. If I've shown you anything, I hope it's that it's never too late!

A special thanks to Team Interweave and both of my editors, Elaine Lipson and Michelle Bredeson, who kept everything running smoothly through many transitions and helped this book come to life.

And last but most assuredly not least, thank you to the Master Artist for the creativity He gives each of us. It's there, you just have to acknowledge it.

resources

Mixed-Media Supplies

Claudine Hellmuth Studio
rangerink.com
Sticky-Back Canvas

Faber-Castell
fabercastell.com
Mixed-media kits, Pitt Artist Pens, Gelatos

Loew-Cornell
loewcornell.com
Brushes and paint tools

Matisse Derivan
matissederivan.com
Paints and mediums, including my signature Mixed Media Adhesive and Liquid Pencil Sketching Inks

Nasco
enasco.com
Safety-Kut artist carving blanks

PanPastel
panpastel.com
Soft artist's pastels in pans

Sofft Tools
sofftart.com
Various tools for arts and crafts, including knives, sponges, and applicators

Speedball
speedballart.com
Block-carving tools

StencilGirl Products
stencilgirlproducts.com
Signature stencil designs by your favorite artists

Uni-ball
uniball-na.com
Makers of the Signo white gel pen

Internet Inspiration

Cloth Paper Scissors
clothpaperscissors.com
Mixed-media community and inspiration

Create Mixed Media
createmixedmedia.com
Art projects, ideas, and mixed-media tutorials

The Sketchbook Challenge
sketchbookchallenge.blogspot.com
Daily sketchbook inspiration

Recommended Reading

Apter, Seth. *The Pulse of Mixed Media: Secrets and Passions of 100 Artists Revealed.* Cincinnati, Ohio: North Light Books, 2012.

Berry, Jill K. *Personal Geographies: Explorations in Mixed-Media Mapmaking.* Cincinnati, Ohio: North Light Books, 2011.

Bleiweiss, Sue. *The Sketchbook Challenge: Techniques, Prompts, and Inspiration for Achieving Your Creative Goals.* New York: Potter Craft, 2012.

Cozen, Chris, and Julie Prichard. *Acrylic Solutions: Exploring Mixed Media Layer by Layer.* Cincinnati, Ohio: North Light Books, 2013.

McDonald, Quinn. *Raw Art Journaling.* Cincinnati, Ohio: North Light Books, 2011.

Shaw, Mary Beth. *Flavor for Mixed Media: A Feast of Techniques for Texture, Color, and Layers.* Cincinnati, Ohio: North Light Books, 2011.

Sokol, Dawn DeVries. *Art Doodle Love: A Journal of Self-Discovery.* New York: STC Craft, 2013.

Trout, Diana. *Journal Spilling: Mixed-Media Techniques for Free Expression.* Cincinnati, Ohio: North Light Books, 2009.

Tuttle, Susan, and Christy Hydeck. *PhotoCraft: Creative Mixed-Media and Digital Approaches to Transforming Your Photographs.* Cincinnati, Ohio: North Light Books, 2012.

index

achromatic, 17
acrylic paint medium, 167
acrylic paints, 165
action drawing, 129, 131
analogous colors, 17
aqua brush, 166
Arcimboldo, Giuseppe, 83
assessing one's work, 4–5, 29; in a journal, 4–5; with a work-sheet, 5
awl, 165

barens. See brayer.
bingo dauber bottle, 165
black gesso, 166
blending (shading), 147
blending stump, 165
blind contour, 129, 131
bone folder, 165
bookbinding needle, 165
bookbinding tape, 166
Braque, Georges, 109
brayer, 94, 166
brush pens, 145, 168
burnish, 164

carving, 91, 93, 94; tips, 94; tools, 94
chip brush, 166
chromatic, 17
clear gesso, 166
clear stamps, 169
cold press finish paper, 7, 169
collage, 164
color wash, 164
colors: primary, 11, 17; secondary, 11, 17; tertiary, 11, 17; wheel, 10–13
complementary colors, 17
Conté crayons, 166
contour drawing, 129, 131
cool colors, 17
craft knife, 166
critique. See assessing one's work.

cross-hatching, 147, 164
Cubism, 109
cutting tools, 166

dip pens, 168
dry-brush, 164
drying retarder, 167

ephemera, 166

face mapping, 157
flyspecking, 164
foam stamps, 169
folio, 164

gel pens, 168
Gelatos, 166
gesso, 166
gesture drawing, 129, 131
glaze, 164
glossary, 164
graphite pencils, 166

heat tool, 166
hot press finish paper, 7, 169
hue, 17

image transfer, 164
impasto medium, 167
Impressionism, 49
inks, 166

journal: keeping and assessing, 4–5; making a, 6–8

kneaded erasers, 167
knife (for carving), 94

linocut, 164
Liquid Pencil Sketching Ink, 167
Loew-Cornell Berry Maker, 167
Loew-Cornell Fine Line Painting Pen, 167

masking, 164
masks, 167
mediums: acrylic

paint, 167; block printing, 167; drying retarder, 167; impasto, 167; surface tension breaker, 167
Mixed Media Adhesive, 167
Monet, Claude, 49
monochromatic colors, 17

negative space, 81, 87, 89
nib pens. See dip pens.

palette, 167
palette knife, 168
PanPastels, 85, 168
paper: cold press finish, 7, 169; hot press finish, 7, 169; kinds, 7; preventing curling, 39; watercolor, 7, 169
paper clay, homemade, 117
papier-collé, 109
pastels. See PanPastels.
permanent pens, 168
Picasso, Pablo, 109
pointillism. See stippling.
polychromatic, 17
positive space, 81
pounce, 164
precision cutters, 166
punchanella. See sequin waste.

resist, 164

scissors, 166
sealants, 168
sequin waste, 168
Seurat, Georges, 49
shading, 147
signature, 164
Sofft tool, 85, 168
space: negative, 81, 87, 89; positive, 81
Speedball Linoleum Cutter, 94
sponge brush, 166
square gouges, 94

stamps, 169
stencil, 168
stencil brush, 166
stippling, 147, 164
surface tension breaker, 167
symmetry, 17

tints, 143
tones, 143
tooth, 164
trails, 164
transfers, 51, 55
transparencies, 55

U-gouges, 94
undercut, 164
under-journaling, 164
unmounted rubber stamps, 169

value, 143
V-blades, 94

warm (color), 17
washi, 168
watercolor paper, 7, 169; cold press finish, 7, 169; hot press finish, 7, 169
water-soluble media, 169
waxed linen thread, 169
wet-on-wet, 164
white gesso, 166
wood-mounted rubber stamps, 169